IMAGES
of America

PEARL RIVER

ON THE COVER: Residents gather in Memorial-Braunsdorf Park on Main Street to attend the 1924 Veterans Day ceremony to dedicate the flagpole and memorial brass plaques to the town's war dead. This photograph was taken from the roof of the Rockland Hotel, next to the Hadeler Building. (Mary D. Kennedy.)

IMAGES
of America

PEARL RIVER

James Vincent Cassetta

ARCADIA
PUBLISHING

Published by Arcadia Publishing
Charleston, South Carolina

Printed in the United States of America

Library of Congress Control Number: 2013950664

For all general information, please contact Arcadia Publishing:
Telephone 843-853-2070
Fax 843-853-0044
E-mail sales@arcadiapublishing.com
For customer service and orders:
Toll-Free 1-888-313-2665

Visit us on the Internet at www.arcadiapublishing.com

This book is dedicated to my wife, Rasa, and to my children, Dominick and David, who put up with my absences and divided attention for two years while I wrote this book. And to my mother, who encouraged me to read. I also dedicate this book to the memory of George Schollian (1937–2009), social studies and English teacher in the Pearl River schools and my mentor, friend, and father figure.

CONTENTS

ACKNOWLEDGMENTS

I would like to thank the following people and institutions for their help in the writing of this book: the Orangetown Historical Museum and Archive (OHMA), the Pearl River Public Library (PRPL), Historical Society of Rockland County (HSRC), Beth Am Temple, Pearl River United Methodist Church (UMC), St. Stephen's Episcopal Church (SSEC), Naurashaun Presbyterian Church (NPC), Excelsior Fire Company, the New City Library, American Legion Post No. 329, Pearl River Alumni Ambulance Corp, the Pearl River School District, SS. Helen and Constantine Greek Orthodox Church (HCGOC), Hook & Ladder Fire Company, Emmett Gallagher, the Alan Cameron family, Mary D. Kennedy, Nancy Moore, Rasa Cassetta, Helen Cooper, Robert Knight, Larry Kigler, Dennis Sherer, Marion Covey, Tom Wainwright, Susan Reynolds, Mary Cardenas, Joe Barbieri, Vivian Dykman, David Slagen, George Potanovic, Elizabeth Skrabonja, Marianne Leese, Marjorie Johnson, Brian Duddy, Lenny McGarvey, Jane Quinlan, Charlie Meyerhoff, David Fisher, Chris Vergine, Don Peckman, Mark Griffith Jr., Glenn Meister, the Beckerle family, Paul and Jeannine Clark, Evan DeVrise, Mark A. Waitman, Vince Angioli, Jean Massaro, Mel Liebman, Tracie Trojan, Kathy Dexter Bogert Baldwin Giroux, Bob Giroux, Tom O'Reilly, Chad Murdock, Martha Murdock, the daughters of John Von Holt Jr., Bob Mishcio, John P. Lock Jr., Rev. Susan Fortunato, Rev. Laura Cunningham, Kenneth Gorton, Mary Hastings, Brian Jennings, Sally Pelligrini, George Schollian Jr., Nan Fabio, Jim and Adriane Fabio, Dorothy Park Godfrey, Don and Susan Peckman, Rabbi Daniel Pernick, and John Young.

INTRODUCTION

The area now known as Pearl River, the second-largest hamlet in New York State, has played host to human habitation since the end of the last ice age, approximately 13,000 years ago. Over the years, evidence of human activity has been found in artifacts unearthed everywhere from the soil in residents' gardens to ancient Lenape campsites along the banks of our streams and brooks. The fill used for the 1922 construction of the Central Avenue School along the Cherry Brook, a once marshy wetland, contained countless arrowheads, which later worked their way to the surface to be found by schoolchildren. Washington Avenue was an Indian trail marked by a tree whose trunk was bent into two 90-degree angles, a marker created by the native Lenape, who shaped and bound the tree while it was growing as a sapling. In 2013, that tree was still growing on the corner of Washington Avenue and Middletown Road.

The Lenape spoke an Algonquin dialect and their language lent place-names like Pascack and Hackensack. The Dutch and English languages also lent names to this area. Naurashaun, for instance, is not a Lenape word but an English corruption of the Dutch name Narratschoen, meaning land that has the characteristics of a high point. In the fall and winter, there is a high point on Sickletown Road, just before the one-lane tunnel, where the New York skyline can be seen to this day. But after thousands of years here, the Lenape were generally gone by 1705. In the 17th century, the area was part of an early-1650s Dutch land patent of 100,000 acres that stretched from the Ramapo Mountains in the north to Carteret, New Jersey, in the south. This claim, staked by the Dutch West India Company, was declared null and void by the States General in Holland because no white man had yet to set foot there, and it was deemed unable to be surveyed. On June 25, 1696, King William III of England gave a land patent to two New York businessmen—Daniel Honan, the accountant general of New Amsterdam, and Michael Hawdon, a privateer, smuggler, tavern owner, and friend of the infamous Captain Kidd. The patent consisted of 35,000 acres and was called Kackyachtaweke, commonly know as Kakiat. Both Honan and Hawdon were Irish Protestants and speculators. After Hawdon died in England, where he had gone to answer charges of piracy, Honan became sole owner. Following Honan's death in 1713, his executors had the land surveyed, paying for expenses by dividing and selling a portion to land speculators. This 1,000-acre portion was known as South Moiety and is part of the land Pearl River occupies today.

Shortly after the 1670s, the first whites to arrive here were Protestant French Huguenots who had become Dutch in custom and culture. They built sandstone homes in the Hackensack River Valley, specifically the Naurashaun area, along with settlers of Austrian and pure Dutch origins. For the most part, settlers staked out the high ground along today's Middletown Road—not in the valley of the Muddy Brook, where Pearl River's business district is today—knowing and learning from the experiences of the Lenape that the Muddy Brook flooded in the spring and fall.

The first English settler was Louis Post, who arrived around 1710. Post settled a 30-acre farm on high ground along Pascack Road. As more English, Dutch, Germans, and Austrians settled here, they started families and grew, farming the Hackensack River bottomland and producing rich produce and flowers in greenhouses, uninterrupted—with the exception of the American Revolution—for 175 years. Then came the industrial revolution.

In 1869, a German immigrant named Julius E. Braunsdorf won a patent court fight against the holders of the patent for the Singer sewing machine. This victory helped give him financial backing to buy 95 acres of flood-prone land along the Muddy Brook. On this land, Braunsdorf gave a right-of-way to the New York & New Jersey Railroad's Hackensack Extension Line, and he constructed the Aetna sewing machine factory near the tracks to build his sewing machines and electrical generators. He imported skilled labor from the region and set about building a community. In addition to establishing a foundry, a lumber and coal store, and a metal castings foundry, Braunsdorf also laid out streets wide enough to turn around his horse and buggy in one motion, three of which he named after his three sons—John, Henry, and William. He laid out Central Avenue and established a post office, park, and a railroad station. He built his own home high on Middletown Road and sold individual lots of

land for homes and other businesses. Soon, hotels, hardware, sundry, and grocery stores appeared, and school was held above the blacksmith shop. This development of Muddy Brook—an isolated, wild, and marshy section of town—gave him the sobriquet "The Father of Pearl River." He was also called the "Forgotten Man of Science." Braunsdorf invented a carbon arc filament bulb, the carbon arc lamps that lit New York City docks, and the generators and lamps that illuminated the Capitol in Washington, DC. But it was Thomas Edison in West Orange, New Jersey, who gained fame and fortune with a patent for his carbon filament bulb.

Around this time, an apocryphal legend held that Sylvester O. Bogert stopped to dig *Unio margaritiferus*, the then plentiful local pearl-bearing mussels, from the Muddy Brook for his lunch. While eating, he bit into what turned out to be a freshwater pearl. And for those pearl-bearing mussels, Pearl River was named. Another, and more likely, story was that Julius Braunsdorf hated when railroad conductors yelled "next stop, Muddy Brook" as they approached the station. He felt that for prospective buyers looking to buy land to start homes or businesses, hearing "Muddy Brook" was not good for business. He complained to the railroad president, who left it to his wife, Mrs. John Demarest, to rename the town after the pearls found in the local brook.

After Braunsdorf's death in 1880, Pearl River languished. The main cash products came from Pearl River farms that produced hothouse roses, milk, apples, corn, and eggs. Braunsdorf's machine works sat empty until another inventive genius, Talbot Chambers Dexter, arrived in 1894. Dexter had patented a machine that rolled, folded, and assembled newspapers in record time, and he moved his company to Pearl River from Phoenix, New York. Recruiting German and Scandinavian skilled labor, the Dexter Folder Company increased Pearl River's population and established a philosophy of community service. Dexter built the Unique Club, which he established as a popular community center and alternative to saloon drinking and loitering. In the 1920s, Dexter started the Park Savings and Loan, which gave low-cost financing to employees for homes on Ridge Street, many of which still stand today. Dexter's company grew to over 500 employees and built more than 75 machines related to the folding, bundling, cutting, and binding of printed material. Before his death in 1930, Talbot Dexter held over 165 patents. Eventually, the company lost business to competition in the United States and abroad. Dexter closed its doors in 1966, when it was bought out by Rockwell International, which ran it until 1975.

Dr. Ernst Lederle, another inventive genius, arrived in Pearl River in 1906 and purchased the old Turfler house and the adjacent 99-acre farm on Middletown Road. On this land, Dr. Lederle, a former health commissioner for the City of New York, established a successful laboratory to produce diphtheria antitoxin and a medicine to prevent pernicious anemia. During World War I, all of the gas gangrene antitoxin produced came from Lederle, and after World War II, the first Aureomycin antibiotic was developed. The Lederle campus grew to 530 acres—so large that, by the early 1970s, it used as much gas, water, and electricity as Albany, New York. Like Braunsdorf and Dexter, Lederle was paternalistic, which fostered employee morale and company success. There were Lederle bowling leagues, baseball teams, and coin, photography, and social clubs. By the late 1930s, the company had become a subsidiary of the American Cyanamid Company. It continued as Lederle until the early 1990s, when it was purchased by American Home Products, then by Wyeth Ayerst, Wyeth, and, finally, by the Pfizer Corporation in 2009.

In general, life in Pearl River remained unchanged until the 1955 completion of the Tappan Zee Bridge, which enabled people working in New York City to purchase homes here. Population growth continued for more than 30 years, and new homes and schools were built. By 2010, the population had grown to 15,837, with roughly 45 percent of the population of Irish ancestry, replacing most of the German, Dutch, and French Huguenot families who settled here originally. The influx of Irish families also gave rise to the hamlet's St. Patrick's Day parade, an event that takes full advantage of Julius Braunsdorf's foresight in planning wide streets and avenues. Since the mid-1970s, the parade has been the second-largest of its kind in New York State.

One

BUSINESS DISTRICTS AND WORKPLACES

The earliest businesses in Pearl River included David "Tanner" Bogert's tannery mill on Washington Avenue along the Cherry Brook and a bituminous coal pit that operated in the Pascack area just before the Revolution. The Leach Stage Coach Inn, a haunt of Aaron Burr, was founded on Old Middletown Road in the late 1700s, and gristmills and sawmills thrived in Naurashaun. Before the Civil War, a Mr. Bush started a general store on Orangeburg Road, and a Mr. DeBaun operated a cider mill across from today's Braunsdorf Park in the mid-1800s. After the Civil War, the Hanft, Comes, Blauvelt, and Bogert families, among others, built greenhouses along North and South Middletown Roads to grow roses for direct shipment to New York City. Overall, however, family farming remained the constant primary enterprise.

In 1872, Julius E. Braunsdorf purchased land in Muddy Brook and invited the railroad through his property. A year later, he began manufacturing generators, printing presses, and sewing machines, which attracted skilled workers and businesses, including the Brookside Inn, Feeney's Hotel, and the Pearl River Hotel. The Hadelers bought Louis Hunt's hardware store in 1906. Meyer's Barbershop offered shaves and haircuts, and a dry-goods store was built by the Rawiser brothers on the corner of Central Avenue and Main Street. Other nearby businesses included Mr. Corby's blacksmith shop, John Braunsdorf's machine shop, Serven's Coal and Lumber, Fisher's Livery Stable, and Everett Palmer's drugstore. In 1894, the Dexter Folder Company set up shop in Braunsdorf's old factory, and Lederle Laboratories was founded in 1906.

The First National Bank and Trust Company of Pearl River was started in 1914, followed by the First State Bank in 1923 and the Park Savings and Loan, started by Philip Beckerle. Chain stores arrived after World War I, including the A&P, National Foods, Food Fair, Finest, Brown Bell, Grand Union, and ShopRite. In 1935, Gertrude Eybers founded the Pearl River General Hospital in an old mansion on Middletown Road. Summer health retreats—such as Matamora, the Milk Farm, the Pines, and Deans Spa—operated on the outskirts of town.

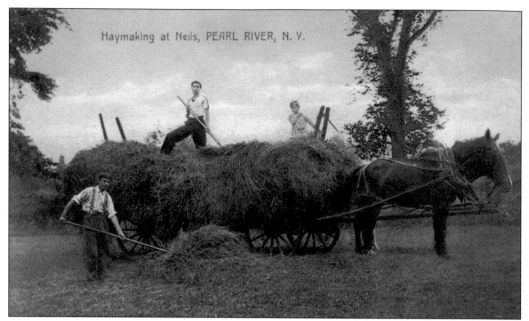

Neil's farm operated on the western bank of the Hackensack River in the Naurashaun section of Pearl River. Taken in the summer of 1909, this image shows members of the family bringing in the hay for their livestock. Nearby was a swimming hole named for the Neil family; it was a popular spot where a large hawser rope hung from an old tree for swimmers to swing out over the water and jump in. (Author's collection.)

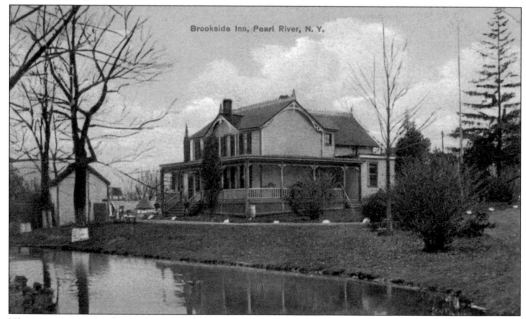

The rustic Brookside Inn operated on the Muddy Brook along the New Jersey border. Built in the mid-1850s as a sawmill, it was sold twice and converted in the 1890s to an old English–style hostelry with a pond for boating. The structure became a string of restaurants known as Hughie's Tavern, Lund's, the Marque, La Forges, Rye's, Bartels, and Texas. It was demolished in 2009, and a medical-arts building stands there today. (Author's collection.)

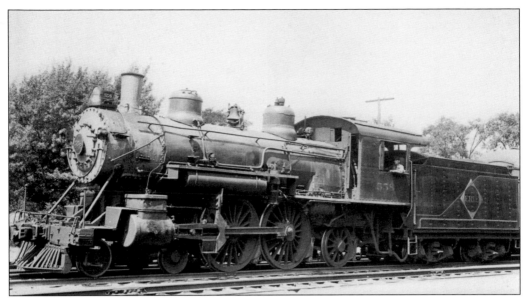

The railroad came to Pearl River in 1871–1872. Julius E. Braunsdorf gave a right-of-way to the New York & New Jersey Railroad in order to build a factory and develop his land holdings. This c. 1930 image shows the Baldwin-type engines that carried people from Pearl River to New York City, Newark, Jersey City, and back in the late 19th and early 20th centuries. (John P. Locke Jr.)

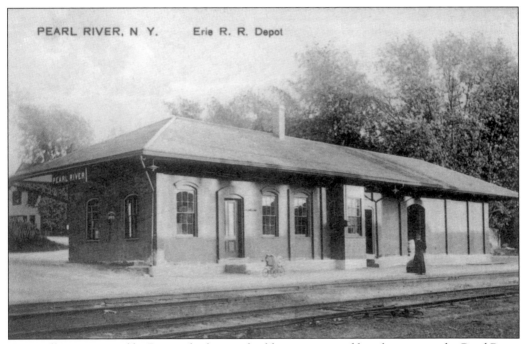

Originally constructed by Braunsdorf as two buildings connected by a breezeway, the Pearl River train station housed a ticket office and a waiting room, which was warmed by a potbelly stove. The buildings were joined after 1880. In the winter, the original station was repeatedly knocked over by snow pushed from the cowcatchers on engines running up and down the line. Though long since used, the potbelly stove remained until the 1980s. (Author's collection.)

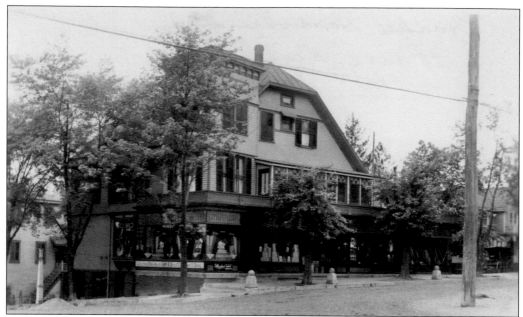

This one of Pearl River's earliest stores, pictured in 1910 at Main Street and Central Avenue. In the early 1870s, a store here was managed by a man named McNiff, for the owner, Julius Braunsdorf. It burned down around 1878. A new structure was built in 1894 by Louis Hunt, who ran it as a grocery store. George Hadeler bought the building in 1906 and began a multigenerational hardware business that continued until 2013. (Author's collection.)

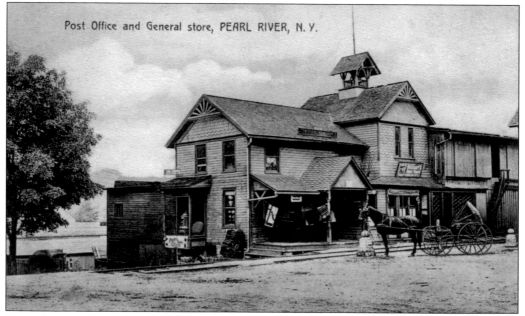

Serven's store, pictured in 1909, originally belonged to Julius Braunsdorf and contained the post office. After Braunsdorf's death in 1880, Serven, who had managed the store for him, purchased it from Braunsdorf's estate and took over as postmaster. Due to its popularity, Serven's was expanded to include more buildings, where it sold items like dry goods, farm implements, feed, clothes, lumber, bicycles, and hardware. It is said that it also had the town's first telephone. (HSRC.)

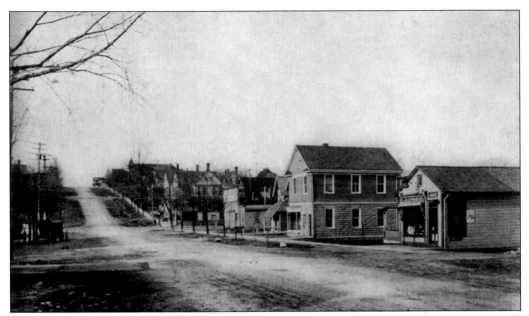

This 1903 view of lower Central Avenue looks west toward what would be St. Margaret's Hill, a favorite place for sledding in winter, and the section of Pearl River fashionably known as "the Heights." Also seen here is the chapel of St. Stephen's Episcopal Church and Everett Palmer's drugstore. The last building on the right before Pearl Street was home to the infamous local pool hall. (Robert Knight and Larry Kigler.)

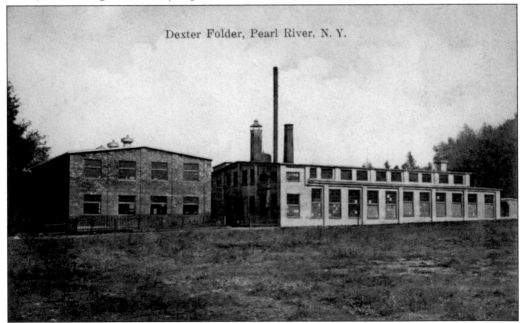

This 1899 image shows the original brick factory works of the Aetna sewing machine factory. Built in 1871 by Julius Braunsdorf, it produced sewing machines, printing presses, electrical generators, and carbon arc lamps. Known for working seven days a week, Braunsdorf died in this factory of a cerebral aneurism while experimenting late into the night. Many people believed that his death was the result of working on the Sabbath. (Robert Knight.)

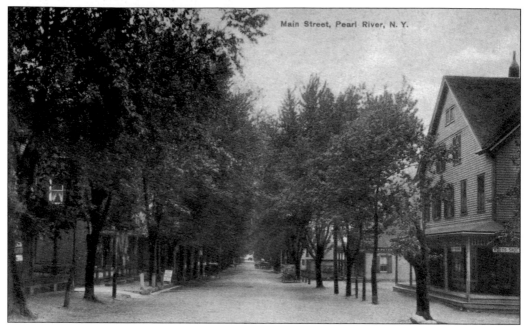

In the 19th and early 20th centuries, North Main and South Main Streets were the central business thoroughfare in Pearl River. Looking south in 1901, the large building on the right was Bader's Hotel, run by Charles and Elizabeth Bader and their daughter Marie. It advertised reasonable rates, meals at all hours, and proximity to the rail station. Note the beautiful elm trees that were planted under the advice of Julius Braunsdorf. (Author's collection.)

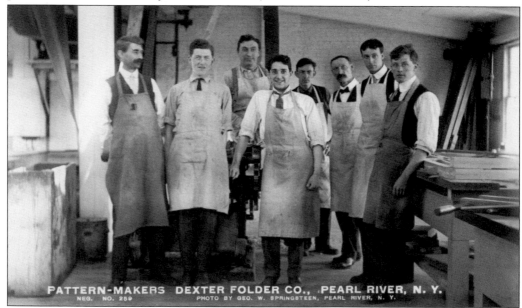

In need of skilled workers for his factory, Talbot Chambers Dexter, inventor of the newspaper-folding machine, hired men like these. Some were native born, like John Secor from Newark, while Frederick Hendrickson (pictured far right) was from Norway. Photographed by George Springsteen in 1912, these men were experienced machinists, patternmakers, and carpenters who passed their skills on to others and whose families helped populate Pearl River. (Nancy Moore.)

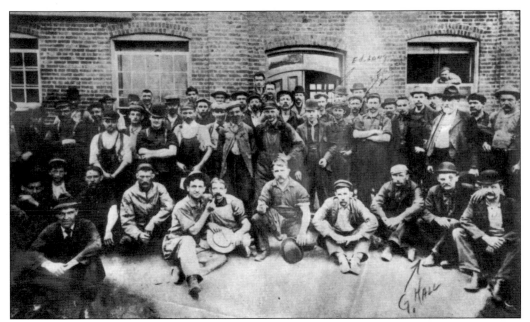

After Julius Braunsdorf's death in 1880, his factory fell silent for 14 years. In 1894, Talbot C. Dexter purchased it and moved his works from Fulton, New York, to Pearl River. This rare 1895 photograph shows the men who moved with him. Among those pictured are Ed Long, Fred Grimm, and George Hall, part of a workforce that would grow to over 500 by the 1950s. Part of the factory is still in use today. (PRPL.)

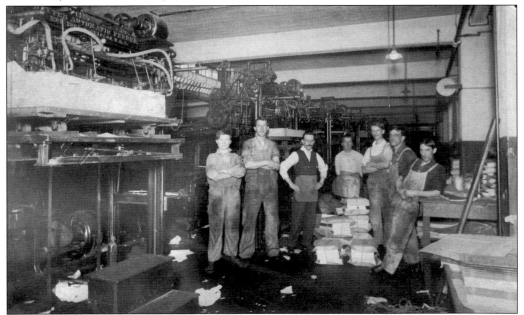

This 1898 photograph shows Dexter Folder workers operating a bundling machine. Machinery like this was made and shipped all over the world. Images like this were rare because setting up a shot like this took time. Talbot Dexter started his business in Des Moines, Iowa, then moved to Fulton, New York, and on to Pearl River to be closer to the print and publishing markets of Jersey City and New York City. (PRPL.)

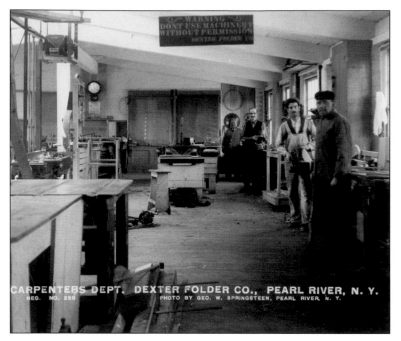

CARPENTERS DEPT. DEXTER FOLDER CO., PEARL RIVER, N. Y.
NEG. NO. 288 PHOTO BY GEO. W. SPRINGSTEEN, PEARL RIVER, N. Y.

This candid shot of the Dexter carpentry shop was captured by George Springsteen in April 1912. These highly skilled carpenters created a variety of shipping crates for anything from individual parts to entire machines. The man sporting a black mustache (standing at the third workbench from the front) is Fred Pipe, who lived in a cottage on Summit Avenue, up on the Central Avenue hill near St. Margaret's Church. (OHMA.)

In this c. 1908 view looking north on Main Street, the gaily painted wagon on the left is not, as some believe, a carnival or gypsy wagon. It is a lunch wagon, paid for by Talbot Dexter to provide hot lunches to his employees. Talbot Dexter was a prohibitionist and no fool—having a place to purchase an affordable lunch kept his workers away from the beer and free lunches in local saloons. (Nancy Moore.)

Franklin Avenue, Pearl River, N. Y.

Taken around 1913, this is a view from Main Street looking east on Franklin Avenue. It shows some of the houses and other structures built by William Springsteen along the left side of the street. On the right side is the brick telephone exchange building, constructed in 1912 at the corner of Ridge Street and Franklin Avenue by LaForest Hopper, grandfather of local news editor Art Hopper. (Robert Knight.)

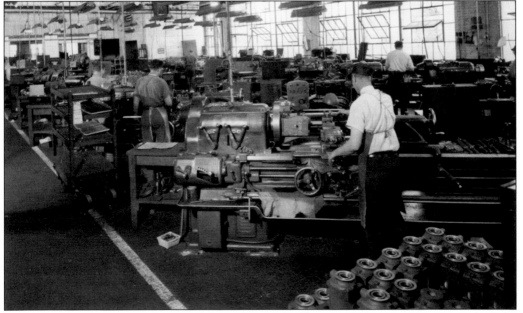

Pictured in 1943 are Dexter's thoroughly modernized milling and lathe rooms. Gone are the belts and pulleys of the 1920s. During World War II, Dexter was an integral producer of the precision parts that went into the planes, antiaircraft guns, tanks, and bombsights assembled at other factories. Dexter employees, both men and women, excelled in their efforts and were awarded an Army and Navy "E" for wartime excellence in production. (PRPL.)

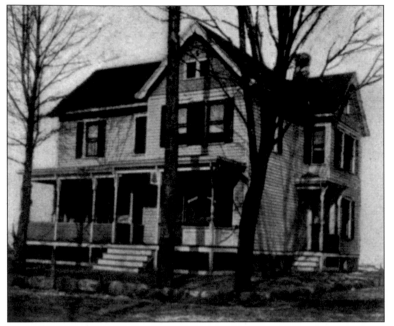

Pictured in 1902, the home pharmacy and office of Dr. Robert R. Felter was located on the corner of William Street and Franklin Avenue. Felter served on the board of the Pearl River Savings and Loan and was a school board president. He was also the second person in town to own a telephone and the first to own a car, a Stanley Steamer that children believed would burn them if they sat on the seat. (Author's collection.)

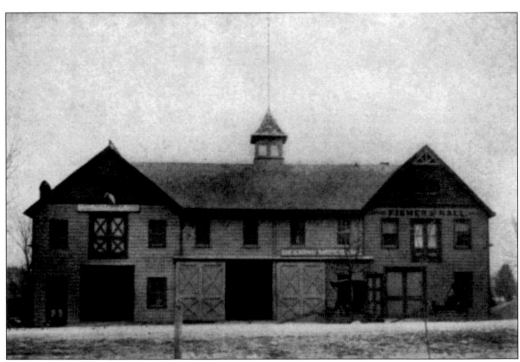

In 1890, Joseph A. Fisher joined two barns to form Fisher's Livery Stable on Central Avenue, pictured here in 1900. Fisher boarded and provided farrier services for horses, stored and rented wagons, graded roads, and moved furniture. In 1917, after a nearby railroad accident spilled grain and gravel, he purchased the grain and unknowingly fed gravel-tainted grain to his horses. They quickly died and were dumped on Hillside Avenue in an area known as Fisher's Dump. (Author's collection.)

Mechanic Frank Mischio's gas and service station was started during the depths of the Great Depression. Located at the corner of East Central Avenue and Middletown Road, it is still used as a service station today. Mischio, who lived on South William Street, later became a Mobil franchise owner and moved to a more modern service station on the opposite corner, where the community message board is today. (Robert Mischio.)

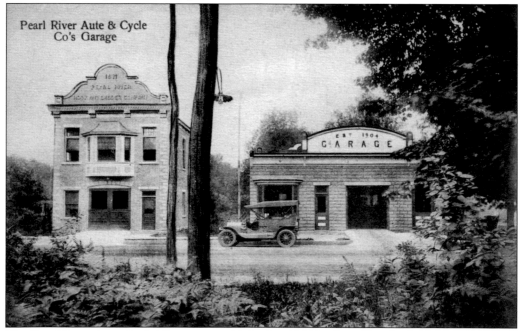

Pearl River Aute & Cycle
Co's Garage

The Pearl River Auto Cycle Shop was established in 1904 by Otto Kossel, who sold and repaired Buicks and bicycles on Central Avenue. This 1915 image also shows the first fireproof station house, the third house built for the Hook & Ladder Fire Company. This building and the station house built in 1969 were the last brick station houses constructed until the company's major expansion in the early 2000s. (HSRC.)

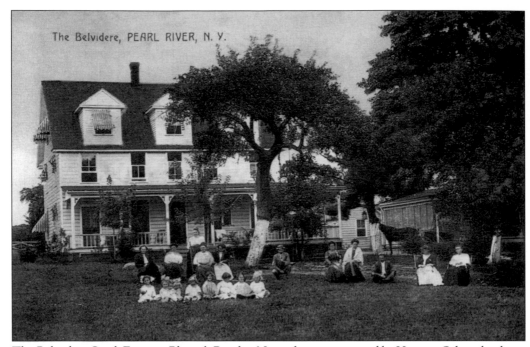

The Belvedere Stock Farm on Blauvelt Road in Naurashaun was owned by Herman Schnackenberg, who, in addition to livestock, offered stud services of Astra, the nationally famous, award-winning purebred trotter horse of the 1890s. The Belvedere also offered elegant summer lodging for city families, like those shown here in 1915. Families would enjoy the country, swim in the Naurashaun Brook, ride horses, or go shopping in Pearl River or Blauvelt. (Author's collection.)

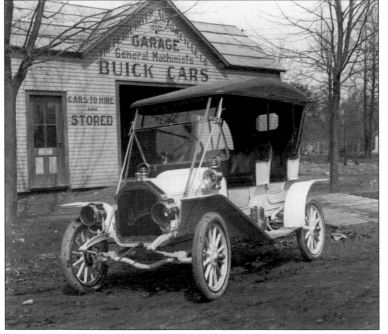

This Buick is parked in front of Kossel's first garage, a wooden structure built in 1904, which was replaced by a safer masonry garage around 1911, after the nearby Hook & Ladder Company station house caught fire and the blaze spread to the building. The fire of 1911 caused all merchants to consider or build fireproof brick structures like Kossel's and the rebuilt fireproof Hook & Ladder Company firehouse. (Mary D. Kennedy.)

In 1915, Grover B. Sanford opened his drugstore in this stone building, which today is the Grand Saloon. Sanford remained here until 1924, when he had a new structure built farther up Central Avenue to get away from the flooding Muddy Brook. During the 1930s and 1940s, this was the hub of youth culture in town. There was a busy soda fountain here as well as the third telephone available for public use. (OHMA.)

Pearl River's first post office was located in Serven's General Store, with Julius Braunsdorf as postmaster. In 1880, James Serven took over that position. In 1915, the new Serven Building on Central Avenue, near the tracks, served as the post office until 1935, when the Bader Hotel was torn down. A new post office was built with federal WPA funds, and Herb Peckman claimed to be its first customer. The building pictured was financed and constructed under an amendment of the Public Buildings Act of 1926. (Robert Knight and Larry Kigler.)

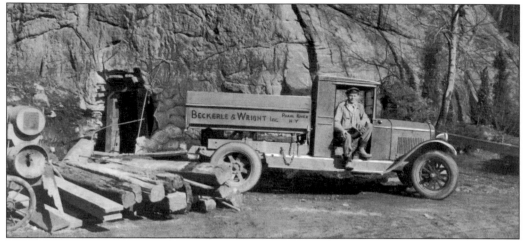

This truck is delivering support timber to shore up the weakened structure of the famous Mine Hole in Piermont around 1925, fulfilling a building contract awarded to Pearl River engineers Jack Wright and Joe Beckerle. Wright and Beckerle operated until 1948. The driver of this truck is taking a break from working to pose for this photograph. (Jean Massaro.)

One of Pearl River's most active businesses was the Wright and Beckerle Engineering Company. In the 1920s, Jack Wright ran a lumber firm with James Titus. After Titus ran off with the company's money, Wright formed a successful partnership with Joe Beckerle. Wright and Beckerle obtained several contracts for Lederle Labs and residential and commercial sewer installations. After Wright's death in 1948, Beckerle formed the partnership of Beckerle and Brown. (Jean Massaro.)

This brick building, constructed in the 1920s, was typical of the commercial structures that replaced the fine residential homes that once lined Central Avenue in the late 19th century. The small wooden building on the left, built around 1900, housed the real estate and insurance office of Gus L. Ansel. After Ansel's death, the Naugle family ran a plumbing business there for many years. Today, this brick building is home to Fordham Pizza. (PRPL.)

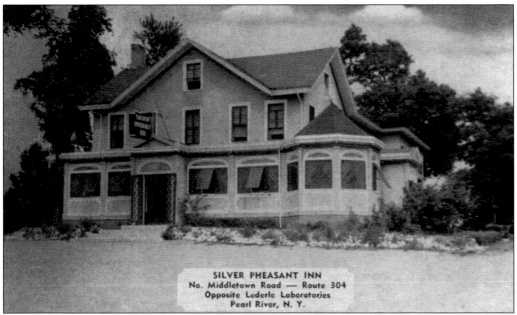

SILVER PHEASANT INN
No. Middletown Road — Route 304
Opposite Lederle Laboratories
Pearl River, N. Y.

Originally home to dairy farmer John Polhemus, this house on North Middletown Road was purchased by Julius Braunsdorf after the Civil War as a summer retreat for his family. He moved here permanently in 1869. His wife, Julia, lived here until her death in 1891. It was then sold and operated as several restaurants. Over the years, it was Paradise Inn, Silver Pheasant, Hudson Bay, Grandma's Pie House, and Keene's; it is currently AquaTerra. (PRPL.)

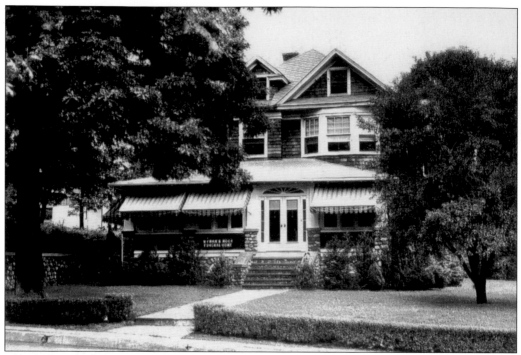

The Wyman Fisher Funeral Home was originally the home of the Wyman family in the 1890s. The home's porch was closed in by Wyman after it was moved from Central Avenue. In the years between the world wars, it became Wyman and Mock, then Wyman Fisher in the 1950s. Today, David Fisher (no relation to Joseph A. Fisher of Fisher's Livery fame) and his stepson Chris Vergine provide funeral services for Pearl River and the surrounding communities. (Wyman Fisher Funeral Home.)

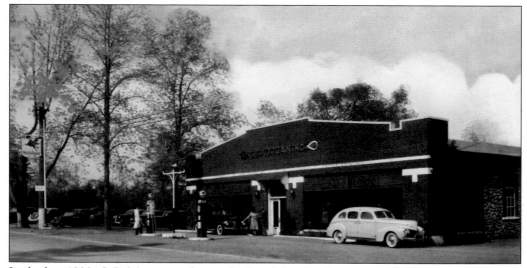

In the late 1930s, L.B. Morgan took over the Smith brothers' garage on Middletown and Blauvelt Roads to start a Ford dealership, which went bankrupt in 1945. Soon after, Ted Schultz took over the franchise. After Shultz relocated, this building housed A.P. King, an auto parts store, which today is Miele Auto Parts. Next door, Mister Softies was a popular hangout in the 1960s. Today, it is the equally popular King Cone. (Robert Knight.)

The Gem Bottling Company was originally one of the two tenements built for Julius Braunsdorf's employees. Notice the sign on the side of the building. Here, the best orange soda in town was made by the Scarpulla family in a garage in the back. Little Ann Angioli is pictured in front of the building in 1940. Scarpulla's trademarked Whistle brand soda was delivered all over Orangetown and Rockland County. (Angioli family.)

After many careers, Herb Peckman started his well-known liquor business on North William Street in an old shack he purchased from former New York Giants player and welder Lee Shaffer in 1947. The landmark store that stands there today was built in 1957 and is run by Herb's son Don and his wife, Susan. The old shack was moved to Stony Point and is part of Gilligan's Restaurant. (Robert Knight.)

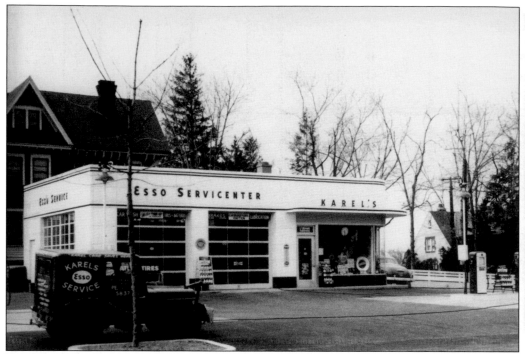

Karel's Mobil gas and service station was established after World War II on the southeast corner of Central Avenue and Henry Street. It was a full-service garage. At one time, this property belonged to the Charles Bargfrede. His daughter Doris became president of the public library board of trustees in the 1960s. (Robert Mishcio.)

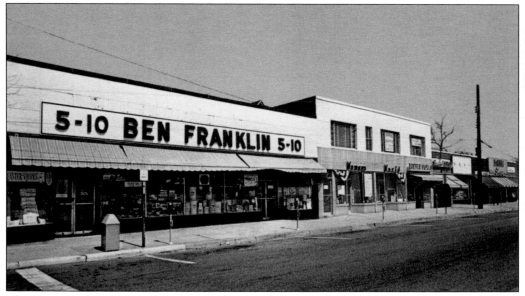

The Ben Franklin five-and-ten store on Central Avenue, shown just before Easter in the late 1950s, is perhaps the most iconic image of Pearl River. It is fondly remembered by generations of Pearl River residents for its candy, toys, peashooters, school supplies, caps, T-shirts, hula hoops, and Duncan yo-yos. The last manager, a Mr. Smith, closed the store in the 1980s after a high increase in rent. (Author's collection.)

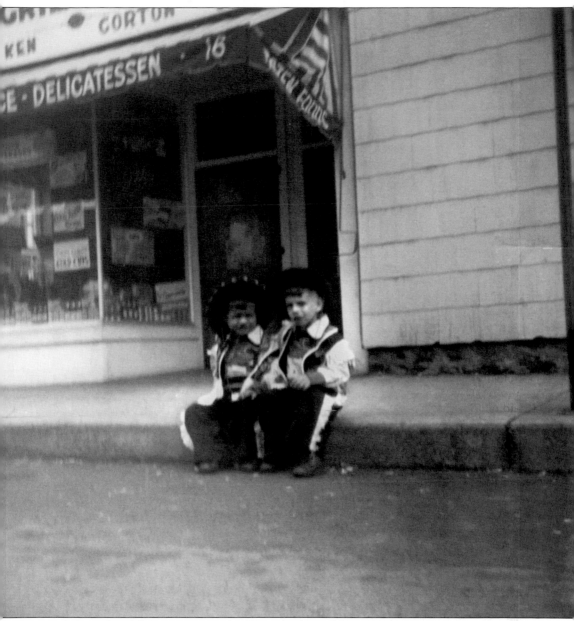

After purchasing this delicatessen on Ridge Street and Franklin Avenue from Joseph Reiber in 1953, Kenneth Gorton named it Pilgrim Market and made it a grocery and deli. To generations, it was known simply as Ken's. Gorton was well liked because families could run a monthly tab for groceries and because he would send local kids on errands, rewarding them with candy or ice cream. Jeffery and Kenney Gorton are pictured in front of their dad's store in 1955. (Kenneth Gorton.)

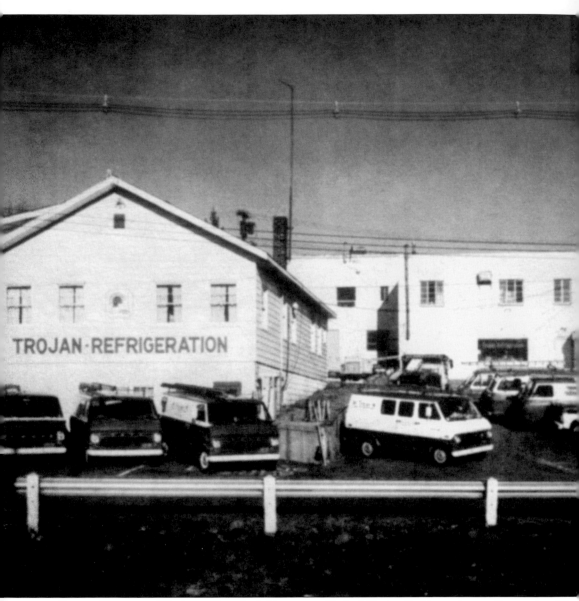

Everett Trojan and Kathryn Demchuk Trojan established Trojan Refrigeration on September 13, 1945. It was the first business of its kind, servicing reefer systems in the 250 apple orchards that operated in Rockland at the time. Trojan also ran an appliance and restaurant-supply business, which closed in 1960. This image shows Trojan Refrigeration at 28 Railroad Avenue in 1964. Today, this building houses the Ancient Order of Hibernians. (Trojan Refrigeration Service.)

Two

FIRST RESPONDERS

Today, there are four corps of first responders in Pearl River. One, the police, consists of full-time paid professionals. The other three—Alumni Ambulance Corps, Pearl River Hook & Ladder, and Excelsior Fire Company—consist of all-volunteer professionals.

Policing in Pearl River started around 1895 with its own constables, who were business owners, and justices of the peace. After World War I, Fred Kennedy Sr. was hired as the night security patrol officer, and his home on John Street served as headquarters. The Pearl River Police Department was formed in 1927 and housed on South Main Street. Kennedy was named chief and given a motorcycle, which he used in raids during Prohibition. By 1935, the Orangetown Police Department was created to patrol all of Orangetown and housed in the still-used police booth in Braunsdorf Park. The Orangetown Police Department moved to the new town hall building in Orangeburg in 1961.

The Hook & Ladder Fire Company on Central Avenue is Pearl River's oldest firefighting service. Started in 1903, it was housed in Fisher's Livery Stable, then in a former feed and grain company, which burned down in 1906 and again in 1908. A fireproof brick building was constructed in 1911, and it lasted until the 1968 construction of a new building, which was expanded in the late 1990s. Excelsior Fire Engine Company began during a meeting at the Odd Fellows Hall in 1912. It was also housed in Fisher's Livery Stable until a firehouse was built on Pearl Street. By 1921, Excelsior and Hook & Ladder merged to form the Pearl River Fire Department. A modern Excelsior firehouse was built on Hillside Avenue in 1968 and expanded in the 1990s.

The most recent of Pearl River's first responders is the Pearl River Alumni Ambulance Corps, which began during a meeting of the Pearl River High School alumni association in 1936. This civic-minded association set out to do what had never been done before in New York State: create an incorporated, all-volunteer ambulance service. After incorporation in 1937, an ambulance was purchased with donated funds to begin making runs to Nyack and Pearl River hospitals. Funds were raised in 1950 to purchase the corps' present building on Route 304, and it is an all-volunteer service to this day.

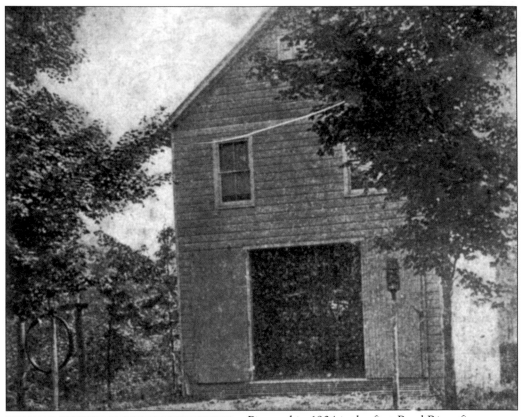

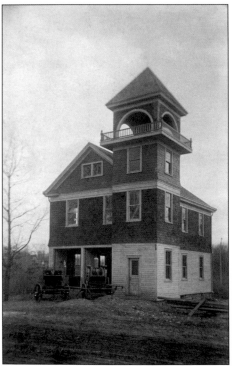

Pictured in 1904 is the first Pearl River fire station. The structure was originally located on the corner of William Street and Central Avenue (where Tucker's bakery once stood), and it later served as a feed and grain store. Members of Hook & Ladder bought the building and had it moved to its present-day spot on Central Avenue on Labor Day in 1904. The station burned down on October 6, 1906. (PRPL.)

After the 1906 fire, a new station house had to be built. The new fire station, built in 1908 for the sum of $1,996, had a four-story hose-drying tower and was the second station house built by local contractor Porter S. Tygert. This building served the company for three years, until another fire consumed the building and all the new equipment inside in March 1911. (Robert Knight.)

Pictured in 1970, this was the fourth Hook & Ladder Company station house, built on the present-day location in 1969–1970 for the sum of $180,000. It was dedicated on October 24, 1970, in memory of two Pearl River firefighters, George Retz and George Pinto, both of whom died during World War II. Retz Drive and Pinto Lane are named for these two men. (Robert Knight.)

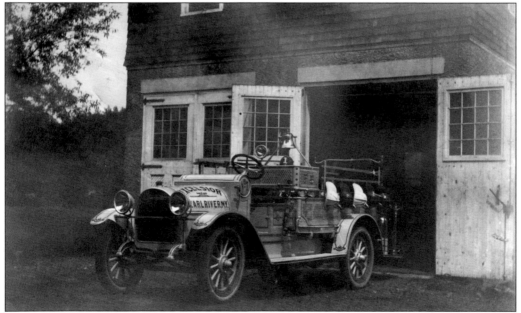

Excelsior Fire Company, Pearl River's second fire company, was organized on February 26, 1912. The first Excelsior fire station was built near the southeast corner of Washington Avenue and Pearl Street for the price of $1,831. This 1922 image shows the house and a pumper truck. This structure was both added to and demolished in 1967 by the state in order to widen Route 304. (Excelsior Fire Company.)

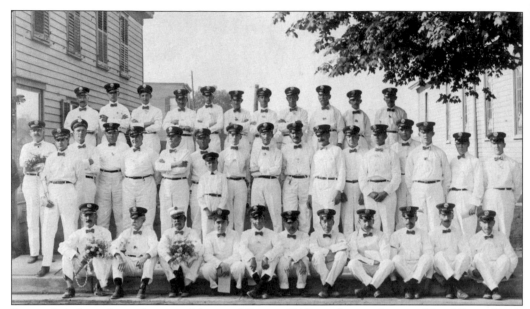

Pictured in their dress whites on Memorial Day in 1915 are the gentlemen of Pearl River Hook & Ladder Company. This image was taken near Palmer's drugstore on lower Central Avenue. Some of the men are holding flower bouquets, which they placed on the graves of American veterans in the Pearl River and Bogert cemeteries, as well as other burial grounds and cemeteries in town. (PRPL.)

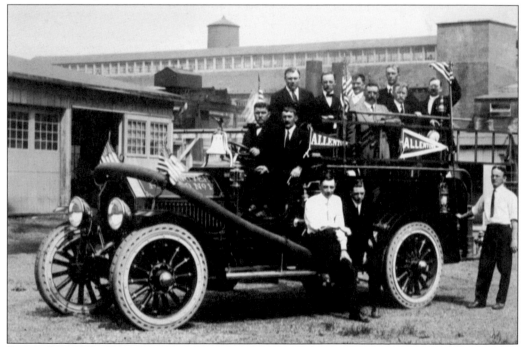

Pictured around 1916 are some of the early officers and chiefs of the Hook & Ladder Company. These men traveled to the Mack Truck factory in Allentown, Pennsylvania, to purchase a new Mack ladder engine. They then drove it home to Pearl River because the cost of shipping it by rail was too prohibitive. (PRPL.)

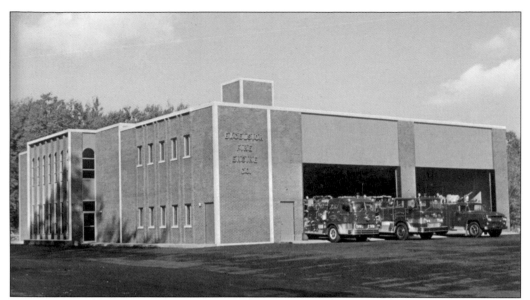

The Excelsior Fire Company lost its firehouse with the construction of Route 304 in 1967. Land along Route 304 just north of the old firehouse was purchased from Lederle Laboratories. A new firehouse was built on the western side of Route 304, next to the Lawrence home on Hillside Avenue. The new Excelsior Fire Company station was dedicated on May 25, 1968. (Robert Knight.)

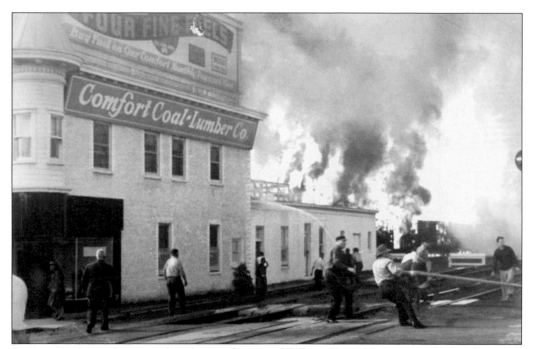

On June 9, 1944, a fire started in the warehouses of Gilbert Blauvelt's Comfort Coal and Lumber Yard along Railroad Avenue. It quickly spread to the rail siding, where six boxcars full of animal feed, sawdust, and supplies for Lederle were stored. Lederle also rented some of Comfort's warehouses, which were filled to capacity with combustible materials, adding to the conflagration. (Excelsior Fire Company.)

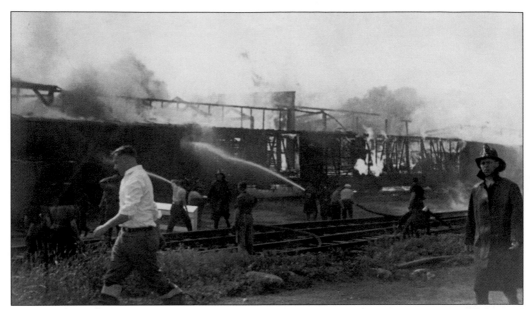

The flames spread at Comfort Coal, burning the boxcars seen in this image. The fire burned for four days, moving into the area now known as the Walter Street Industrial Terminal, which then contained many small shacks and barns. Only minor injuries occurred. Fire companies from Nanuet, Spring Valley, Montvale, Rockland State Hospital, Camp Shanks, Pearl River Police and Ambulance, and Orange and Rockland Utilities helped put out the fire. (Excelsior Fire Company.)

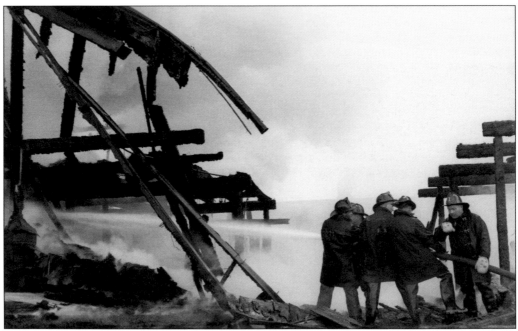

Mutual-aid drills helped prepare volunteers for catastrophic fires, such as this barn burning to the ground on the property of the Lederle Laboratories. Here, Excelsior firefighters aid the Lederle Fire Department in putting out this blaze in the mid-1960s. (Excelsior Fire Company.)

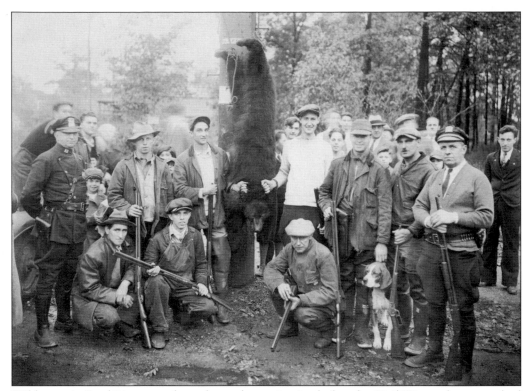

Wild game in Pearl River was almost hunted to extinction before the Civil War, and raccoons had disappeared by the 1880s after James J. Blauvelt shot the last one on his farm on Gilbert Avenue. Residents spotted this black bear along Middletown Road in 1936. Chief Fred Kennedy and Lieutenant Birch gathered a posse of dogs and hunters to track down and kill it on the property that today is AquaTerra restaurant. (Mary D. Kennedy.)

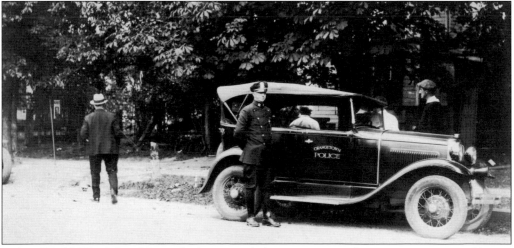

Before World War I, Pearl River had a constabulary consisting of two part-time constables. In 1924, Fred Kennedy, known for his military experience on the Texas-Mexico border, was hired as a security patrol officer. This 1930 photograph shows Chief Kennedy standing with the town's first patrol car. Before this, he often had to respond to calls by taxi. Orangetown became Rockland's first police force to have two-way radios. (Mary D. Kennedy.)

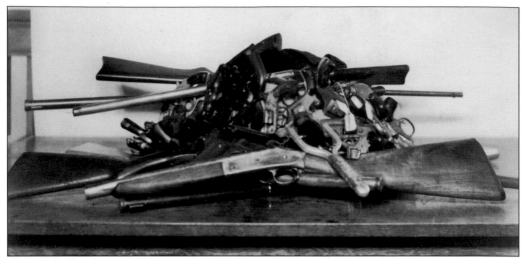

These weapons were confiscated by police in the Pearl River and Naurashaun areas from 1935 to 1940. Any weapon used in a crime, no matter how small, was confiscated, as were weapons that violated New York's 1911 Sullivan Act or other state and local ordinances. Some of these weapons, like the slingshot, were homemade. Factory-made weapons that were confiscated included illegally altered sawed-off shotguns. (Mary D. Kennedy.)

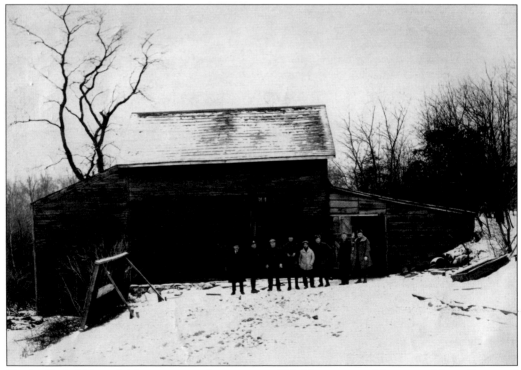

During Prohibition, this barn was on the property of M. Montgomery Maze, near Noyes Street off Orangeburg Road. After Maze reported that someone was using the barn without his permission to make bootleg alcohol, Chief Kennedy—together with Sherriff Dorman, Deputy Sheriff Jones, and Sergeant Kober of the state police and others—conducted a raid on the barn on March 1, 1931, and arrested the bootlegger (in the white coat). (Mary D. Kennedy.)

This image shows Chief Kennedy, George Oakley, state trooper Cliff Quinn, and *Journal News* reporter Skinner with a prisoner arrested in a 1931 raid in which a large amount of beer was destroyed. This was the largest raid in Rockland County during Prohibition. Most raids were unsuccessful because bootleggers were usually tipped off and gone by the time police arrived. (Mary D. Kennedy.)

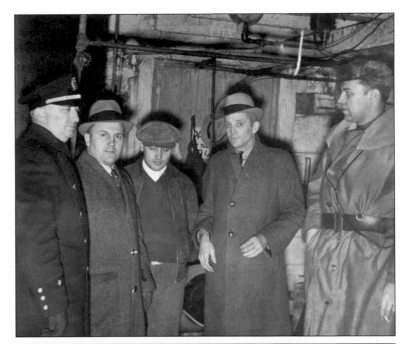

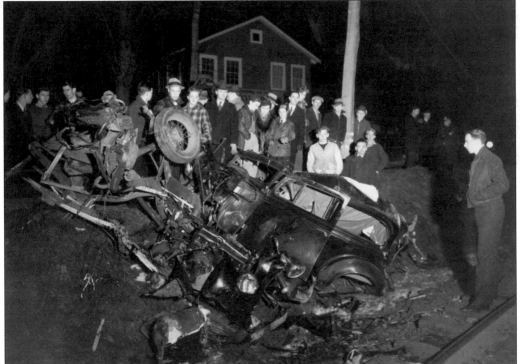

This 1936 wreck at the rail crossing at Washington and Railroad Avenues occurred before signal gates were installed. Three women driving across the tracks were seriously injured when their car was struck by a train. Residents had to drive the women to Nyack Hospital, but they had all bled to death by the time they arrived. This incident resulted in the establishment of the Pearl River Alumni Ambulance Corp in 1936. (Mary D. Kennedy.)

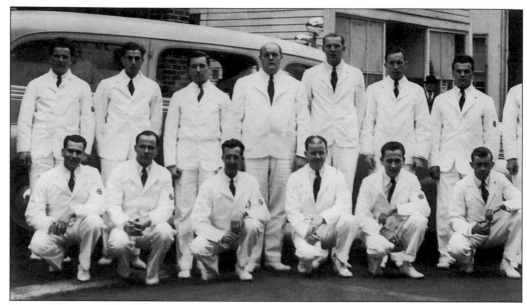

Pictured here are the charter members of the Pearl River Alumni Ambulance Corp with their first ambulance, a new LaSalle-Miller purchased for $2,606 in 1938. The Alumni Ambulance Corp is an all-volunteer service funded entirely by donations. Among those pictured are Mike Youda, Louis Dolan, Bill Evans, Herb Straut, Arthur Langer, John J. Tierney, and Howard Gable, who drove the ambulance home from the factory in Ohio to save on freight charges. (Alumni Ambulance Corp.)

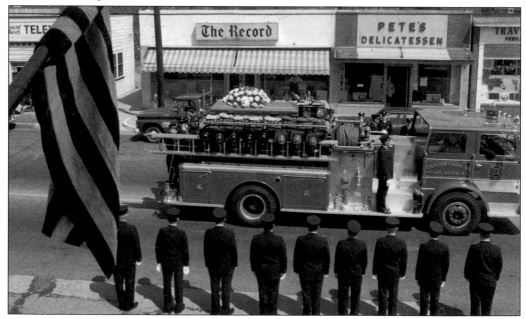

The coffin of Cordes Lucas passes up Central Avenue on the morning of May 26, 1966. Lucas is being saluted for the last time by members of the Hook & Ladder Corp of Pearl River. For many years, he and his wife, Julietta "Grandma" Lucas, manned the central call box located in their home on Serven Street. A member of the Excelsior Fire Company, Cordes was a custodian at the Naurashaun Elementary School. (Excelsior Fire Company.)

Three

LANDMARK HOMES

There were, and still are, many old and beautiful homes in Pearl River. While some disappeared with the ravages of time, others were demolished by the march of progress. Many of these homes were built by the movers and shakers of the time. During the 18th century, two particular types of building materials were harvested and used. The first, native sandstone, was plentiful and easy to excavate, cut, and shape. The second was wood, which, though plentiful and easy to work with, was not fireproof or as durable as sandstone.

Among the still-standing sandstone homes of Pearl River is the Cuyper-Van Houten House, built in 1732 on Sickletown Road in Naurashaun. Built around 1758, the Sickles-Vanderbilt Home once stood in the same area but fell into ruin. The Mackenzie-Lawler House, located at the foot of Orangeburg Road, was built around 1750, and the Perry-Horne House on Elizabeth Street, built in 1752, still shows a few holes, made by Tory musket balls, above the door molding. Some of the remaining wooden homes in Pearl River include Anderson's Villa on North Main Street, built in the 1880s, and the James Van Houten Jr. home on Sickletown Road, opposite the farm stand that operates there today, which served as a coach stop during the Civil War. The Conques-Salyer House on Old Middletown Road has stood since 1730 and is listed in the National Register of Historic Places. The Hillman house on Pascack Road has remained since about 1900. The 1864 Braunsdorf mansion on Middletown Road still stands, and the 1880s Doscher Mansion, with its glass conservatory and high turret spire, was destroyed to make way for a Finest supermarket in the 1960s. The home that once was the Stage Coach Inn, built in 1763 and a favorite haunt of Aaron Burr, still stands at the head of Orangeburg Road.

The construction of the Lake Tappan Reservoir destroyed many old Dutch sandstone homes when they were flooded by damming of the Hackensack River in Harrington Park, New Jersey, between 1962 and 1966. The 1770 Sharples house, which stood on Orangeburg Road, was destroyed by developers.

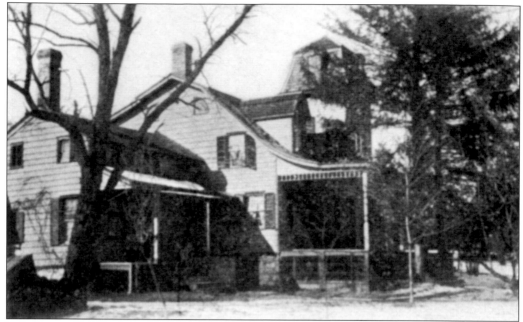

The VanZant family home, built around 1760, stood at the head of Blauvelt Road, where the Citgo station is today. The original part of the home was in the Dutch farmhouse style, but it was expanded to include a Victorian porch and a French mansard-style roof on the tower in the 19th century. The evergreen on the front lawn was planted to bring good luck. The home was torn down in the late 1950s. (Author's collection.)

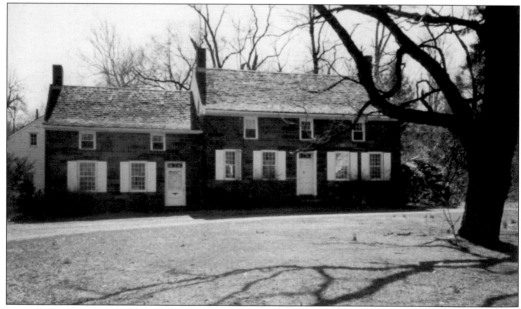

This 1732 home on Sickletown Road is the second-oldest in Pearl River. Built by Tunis Kuyper, who sold it to Rulef Van Houten in 1812, the house was on a property that included 13 acres. Van Houten expanded his holdings to include a thriving farm and mill and named the area Van Houten Mills. His house, a fine example of Hackensack Valley Dutch sandstone architecture, remained in the family until the 1990s. (OHMA.)

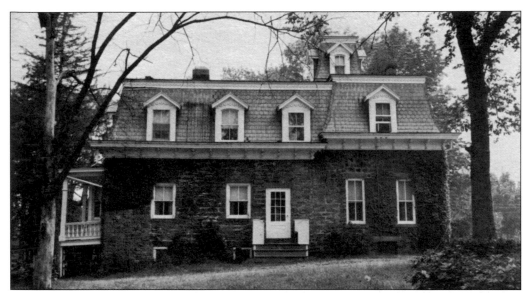

The sandstone Mackenzie-Lawler House at the bottom of Orangeburg Road was built in 1750. In Colonial times, it served as a jail and a bank, and in the 19th century, it was owned by the Mackenzies, whose son became a doctor and served the Orangeville–Pearl River area. One of the Mackenzie daughters, Helen, taught Sunday school in the local Presbyterian church. After it was purchased by the Lawler family in the 1890s, the home was owned by Sam Kennedy, who lived there until the late 1980s. (Robert Knight.)

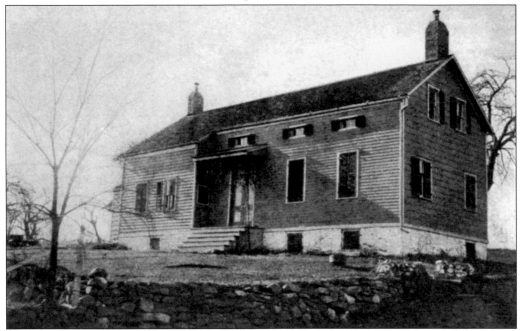

Located on Crooked Hill Road, this house was built around 1790. During the Civil War, it served as the summer home of New York City poet, engraver, and children's-book illustrator Mortimer Houseworth. Houseworth later became a permanent Pearl River resident. His son, also named Mortimer, was active with the Pearl River Boy Scouts around the time of World War I. Today, this historic house is a private home. (Author's collection.)

Known as the Pete Nelson Stage Coach House, this home was a favorite stop for drovers bringing livestock south to sell at area markets. It was built in 1763 as a hotel and tavern, where a barmaid named Leach was courted by Aaron Burr. Slaves were held on the property. The house has been owned by a succession of people over the past two centuries, and the Rindler family has carefully restored it and resides there today. (Nancy Moore.)

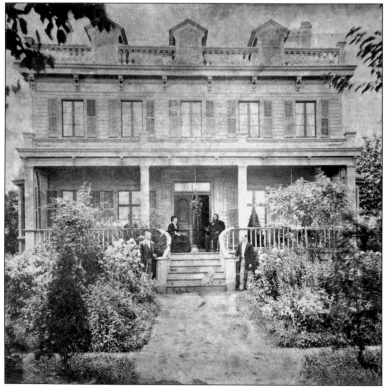

The Morse mansion stood where 300 Middletown Road is today. Owned by John and Mary Morse (seated on porch), it was the summer scene of many social gatherings in the mid-19th century. A New York businessman who lived in Brooklyn and summered in Pearl River, Morse leased the house and returned to Brooklyn in the mid-1870s. It was demolished in 1965. Pictured by the steps are Charlie and Joe Kennedy, relatives of Chief Fred Kennedy. (Nancy Moore.)

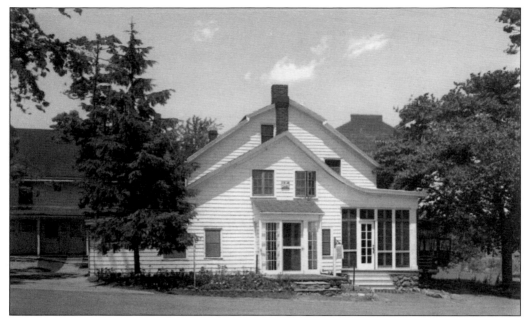

Built around 1786 by the Turfler family, this wooden home used mud and straw for insulation. It is said that John H. Blauvelt, Pearl River's first blacksmith, and his brother David Blauvelt, the town's first doctor, were born here. It was later owned by Jacob Turfler, who sold it to a Mr. Mueller, who then sold it to Dr. Ernst Lederle. Lederle Laboratories used it as a hospitality center and its security department office. (Author's collection.)

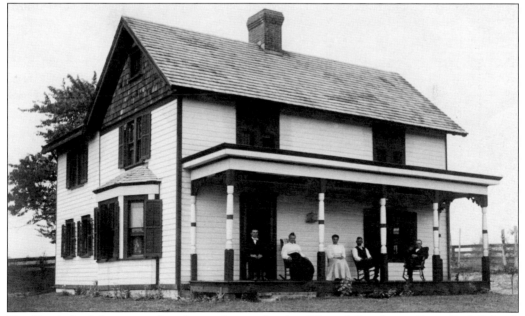

The Vanderbeek house stands today on the north side of Blauvelt Road, near Evans Park School. Edgar Vanderbeek was a gentleman farmer who grew flowers in greenhouses on his property. He also loved to ride around town in his horse rig. The style of this house, built around 1870, is typical American farmhouse. The house was owned by Gerard Rassert from 1919 to 1945. It has been added to in the back but retains the original porch. (OHMA.)

.As seen in this 1900 photograph of the Dosher home, the back of this house had a glass conservatory for plants. The home's high turret and large wraparound porch made it a true landmark in Pearl River. The house and land were sold to a developer, who constructed a Finest supermarket in its place in the early 1960s. Many of the old homes in Pearl River similarly fell victim to commercial development. (Robert Knight.)

Pictured in 1898, this house at the bend of Old Middletown Road was once the home of Capt. David B. Everett. Originally from Rockland, Maine, Everett was involved as a captain in the clipper-ship trade to South America, sailing around Cape Horn in merchant ships. Today, the barn by the house is gone, but the well is still present. The dog, named Carlo, belonged to Everett. (KBDBG.)

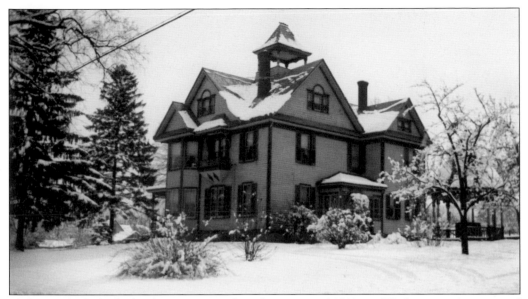

Philip Beckerle built this home, pictured in the winter of 1914, on Washington Avenue and Summit Street in the 1890s. Beckerle was born in Germany and came to America as a small child. He married Pauline Miller of Naurashaun and took over the local sawmill. Beckerle raised a large family in this house, which was torn down to make way for the parking lot of St. Margaret's gymnasium. (Beckerle family.)

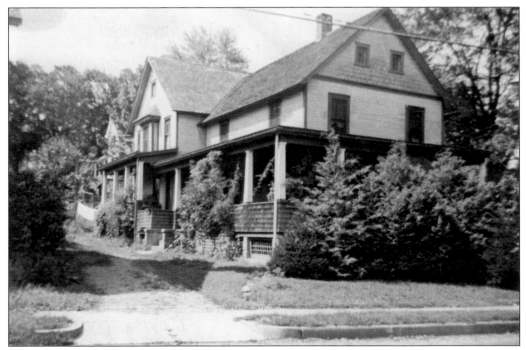

This simple farmhouse at 11 Pearl Street was the home of Porter S. Tygert, a carpenter and contractor. Born in 1862 in Pearl River, Tygert built the second firehouse in 1908 and organized the first Dexter Folder marching band. Victor Prezioso added to this house in the 1920s and raised his family here. Now a rental property, the house faces the expanded Route 304. (PRPL.)

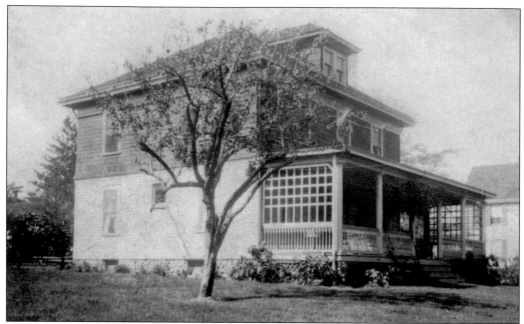

Located across from Captain Everett's home and next door to the Stage Coach Inn, this residence was built on Old Middletown Road in the early 1880s. It was the home of Dr. Albert Osborn Bogert, who was born in Pearl River in 1851. From this house, Bogert would make house calls throughout Pearl River. By 1903, Bogert moved to the more populous Spring Valley, where he could do more business. (KBDBG.)

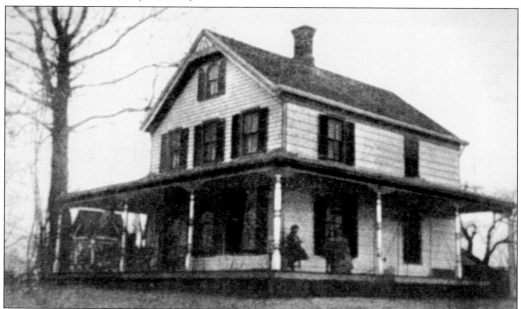

Standing somewhere on the hilltop of West Washington Avenue, this farmhouse was owned by Chief Henry W. McAdams, who purchased the home and property sometime in 1897 or 1898. A fireman in Manhattan, McAdams was instrumental in establishing the New York City School of Fire Instruction not long after civil-service training standards were implemented in New York State. The fate of this house is unknown. (Author's collection.)

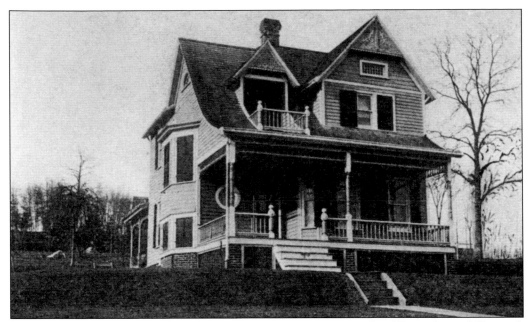

This home stands behind two large pine trees on Route 304 next to Pearl River Animal Hospital. It belonged to Irvin Hall Dexter, the son of Talbot Chambers Dexter. Irvin worked at Dexter Folder, then stuck out on his own, starting a tire company. This home was sold out of the family when Pearl Street was widened in 1965. It is known for its distinctive curved roof that holds a balcony. (Author's collection.)

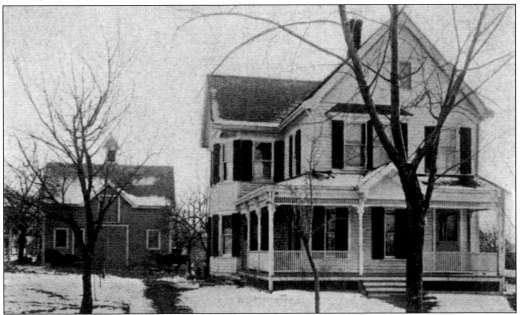

Claus Gerdes, who was the president of the council at Good Shepherd Lutheran Church in 1903, built this house on Central Avenue in the 1880s. Today, it houses the law offices of O'Connell and Reilly. It still retains much of its original Victorian charm, as seen in the barn in back and the porch. The Hoag family remodeled it in the 1980s, and lawyers bought it for their business in the 1990s. (Author's collection.)

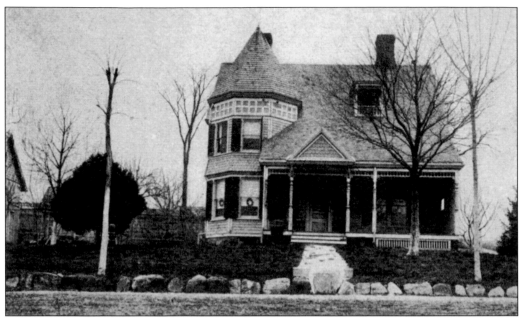

The first home of William Serven was built on the corner of South Serven Street and Central Avenue. William worked in the family general store with his father. His family later occupied the mansion on Pearl Street called Roxmont. William's son James E. Serven was a writer for *Field & Stream* and *Outdoor Life* magazines. He moved to Arizona in 1940 and became an expert on Colt firearms in the 1960s. (Author's collection.)

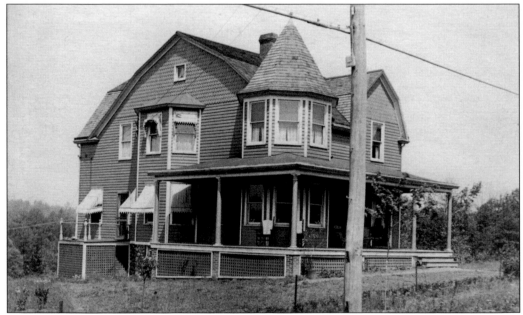

This 1913 photograph of Herman Ahern's summerhouse shows a large home that was the center of social parties among the Pearl River business set in summer months. Ahern had a haberdashery business in New York City and summered in town with his family. He commuted to work on the Pascack Valley Line and came home on weekends. This home still stands on North Main Street, clad in vinyl siding and without its porch. (OHMA.)

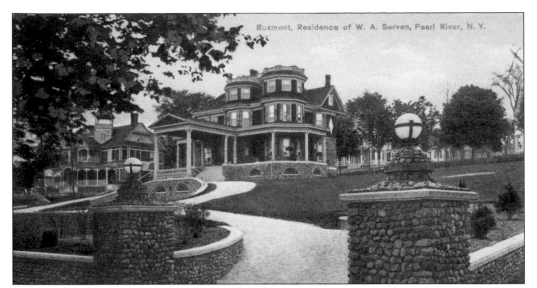

Roxmont, named for the rock fence and hill it was built on, stood on Pearl Street and Central Avenue. It was the second home of James A. Serven, who was known publicly as an energetic and continually busy man. Serven's wife, Margaret, was killed by a local train at a young age. After 1920, the house sat empty until it burned down in 1931 as Pearl River's two fire companies fought over who would put it out. (Author's collection.)

The home of the Hunt family, who owned a popular grocery store, still stands today on the east side of North Main Street and, except for a front dormer, has changed little. Built around 1914, it has stood the years by being well cared for. It is a rental-property apartment house today. (OI IMA.)

Designed by William A. Campbell, this large three-story building was constructed on William Street and Central Avenue to house Viking Lodge No. 761 of the Independent Order of Odd Fellows in 1905. Silent movies were shown, and fraternal meetings and Washington's Birthday dances were held here. Herb Peckman's mother kept the place clean as a porter. It was torn down in 1955 to build the current strip of stores. (Robert Knight.)

For generations of people, this was the most famous swimming spot in Pearl River, the legendary 40 Foot Hole behind the Sickletown Cemetery. It was created on October 3, 1903, when a northeaster caused the Hackensack River to race so powerfully that it tore a large, deep section from the bank. This same storm washed out all the bridges and put lower Central Avenue and Pearl Street underwater. (Robert Knight.)

Taken near the Flat Rock swimming hole of the Pascack Brook in the winter of 1910, this image brings to mind stories of people like Helen Post, whose father would harvest nutritious wild winter cress here during the cold months. It helped prevent pellagra in children. Many people would pick wild plants along the Pascack Brook to use as folk remedies, which were passed down from generation to generation. (Beckerle family.)

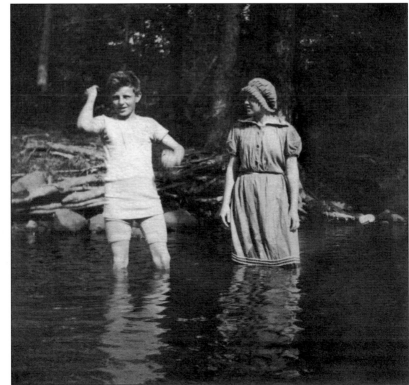

Joe Beckerle and his sister Pauline wade into the Pascack Brook at the swimming spot called White Rocks around 1910. White Rocks was a favorite summer spot on the brook for all the children living west of Pearl Street. Here, Joe gives a Tarzan pose before he enters the water. A changing house was located nearby at a place upstream called Soule's. (Beckerle family.)

These two unidentified boys sitting on the banks of the Muddy Brook are enjoying the view around 1950. The Muddy Brook flows south from Lake Lucile in New City. This stone bridge over Jefferson Avenue was built in 1910, replacing a white wooden bridge. It was in these waters that pearls were discovered in the mussels that once thrived here, inspiring the name Pearl River for the town after 1872. (Robert Knight.)

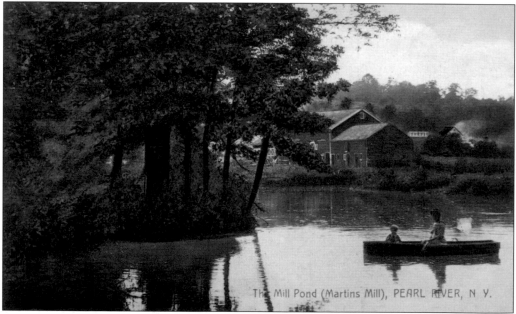

The Mill Pond (Martins Mill), PEARL RIVER, N Y.

Between the Pascack Brook and Pascack Road stood the 19th-century gristmill called Marten's Mill. The home here served as a tavern in the 18th century. The milldam created a pond on which people would boat, as seen in this 1911 image. The brook flowed over the falls, behind which shallow caves were said to be used by the Lenape Indians. Today, the house is the Jade Village restaurant. (Author's collection.)

Pictured in 1938, Gardiner's Pond on the Cherry Brook was created by James J. Blauvelt at South Middletown Road and Gilbert Avenue to provide water for his greenhouses. Depending on the season, local children, among them Gerri and Nan Crosbie, would ice-skate, play hockey, and sail model boats here. In the 1960s, the pond was filled in to build the Meyer Oval neighborhood and Cherry Lane. (Nan Crosbie Fabio.)

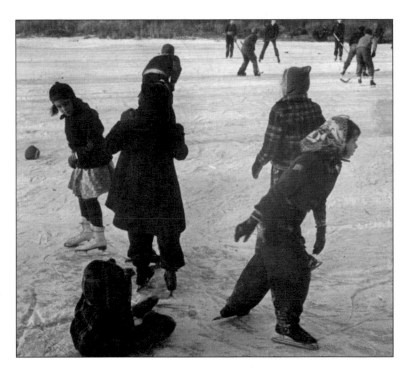

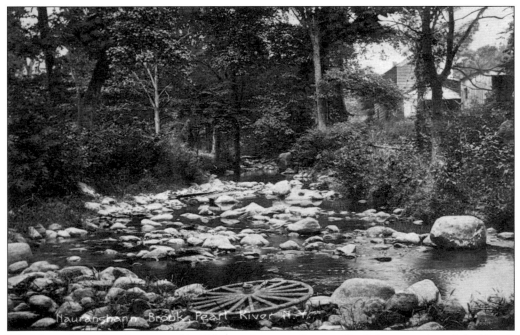

The Naurashaun Brook, pictured in 1912, got its name from an English corruption of the Dutch name Narratschoen, meaning a promontory of land or high point. Both early settlers and the native Lenape used wooden fish traps in this brook, lending to the area the name Fuiken, taken from the Dutch word for fish trap. The buildings on the right bank are thought to be those of Morris Van Houten's farm. (Robert Knight.)

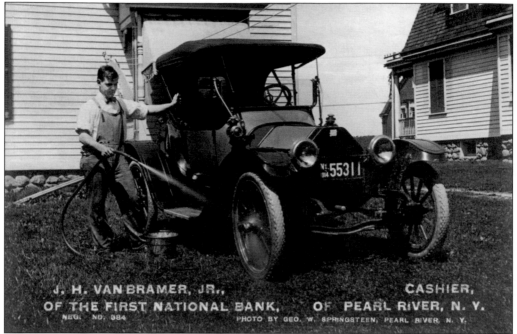

J. H. VAN BRAMER, JR., CASHIER,
OF THE FIRST NATIONAL BANK, OF PEARL RIVER, N. Y.
NEG. NO. 384 PHOTO BY GEO. W. SPRINGSTEEN, PEARL RIVER, N. Y.

J.H. Van Bramer Jr., cashier for the First National Bank of Pearl River, mixes two leisure-time activities—washing his car and having his picture taken with his automobile on his day off. This photograph of Van Bramer was taken at his home on North Main Street by his neighbor George Springsteen. (OHMA.)

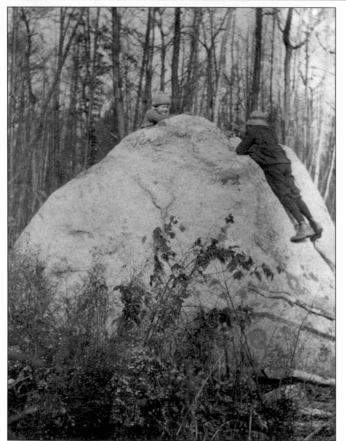

David Cordukes (left) and Russell Dexter climb on a favorite landmark hidden in the woods of Dexter's Children's Park on Pascack Road in 1916. The land belonged to the Dexter family in an area known both as South Spring Valley and West Pearl River. It was given to the town by the family to keep it partly wild and partly developed in perpetuity. Children today still climb on Dog's Head Rock. (KBDBG.)

Gus Ansel took this photograph of his daughter Anne enjoying a piece of watermelon with her pet cat in 1902. Children were rarely photographed in such candid moments; most were instructed to hold ridged standard poses. Anne's father sold real estate from two offices in Pearl River, one near the railroad tracks and the other on Central Avenue. Ansel used Anne's image to promote the bucolic atmosphere of Pearl River. (Author's collection.)

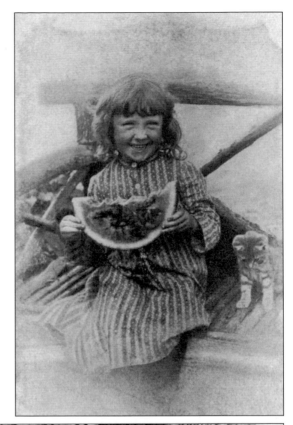

Maria's Rock was deposited in front of what is today's Pfizer plant by the last glaciers. Legend has it that Maria, a 10-year-old Dutch girl from Tappan, wandered away from home in 1730. Becoming lost, she came upon this boulder, fell asleep, and died of exposure. Her skeleton was found by hunters the next spring. Townsfolk would picnic nearby but never at night. Supposedly, the cries of little Maria can still be heard at dusk. (OHMA.)

Riding on a beautiful spring day in their Sunday finest was a popular pastime in 19th-century Pearl River for young couples. This 1908 image shows a nattily dressed man and woman driving down Central Avenue in a horse-drawn rig, perhaps courting or going to visit friends. They are going past the spot on Central Avenue where Ringner's furniture store is today, opposite the old Central Avenue School field. (HSRC.)

The mecca of leisure in 19th-century Pearl River was the Unique Club, built in 1894. This 1915 photograph shows the hose-drying tower and manager's home, additions put on by Porter Tygert. As the club's popularity grew, attractions were added, including a bowling alley, basketball court, baseball stadium, and a soda fountain that served Serven phosphates. The club was Talbot Dexter's plan to keep folks out of the saloons. (Author's collection.)

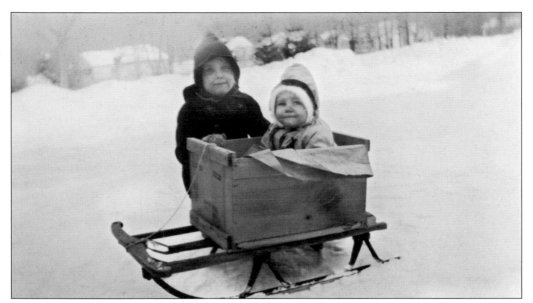

Popular winter activities, such as sledding, could be enjoyed in the winter months. Pictured during the snowy winter of 1948 in the backyard of their home on Prospect Street, Russell H. Dexter's daughters Barbara (left) and Kathleen enjoy the sled that their dad made by attaching a box to a Flexible Flyer sled. (KBDBG.)

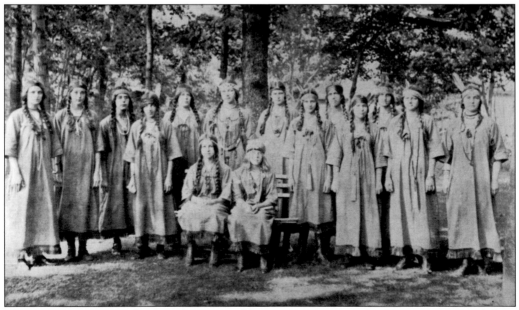

The 1908 Camp Fire Girls of Pearl River would camp out in various places in town. Pictured, from left to right, are (first row) Madeline Lake and Carin Cardell; (second row) Marion Henderson, Mary Creighton, Amy Lowenstein, Flossie Winter, Helena Clauson, Marie Doscher, Vera Creighton, Josephine Rieber, May Lake, Eva Eiserman, Arlene Van Zandt, Rose Rieber, and Bessie Tappey (leader). (OHMA.)

With the arrival of the automobile, every young man who was anyone had to have one. Such was the case with Beckerle Lumber founder Laurence Beckerle in 1915. Here, he and his younger brother George pose in a Jordan automobile, which the family sold from the building on the corner of Jefferson Avenue and South Pearl Street. The boys have this car parked behind the home of their father, Philip, on Washington Avenue. (Beckerle family.)

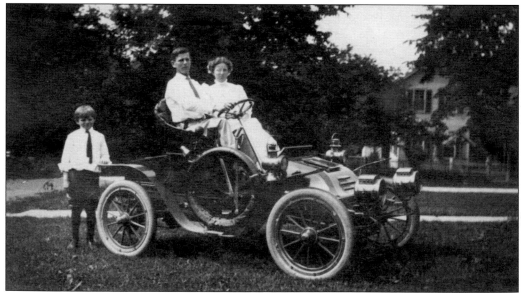

In 1907, John, George, and Margaret Beckerle pose for this photograph on the lawn where St. Margaret's School would be built decades later. The automobile is an early model Winton touring car. Going on motor trips to local spots of interest, like Bear Mountain State Park on the Hudson River, was a wonderful way to pass the time on Sundays. (Beckerle family.)

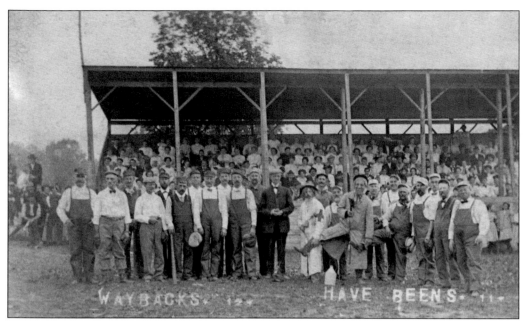

During the 19th century, baseball was the most popular outdoor sport in Pearl River. In this c. 1907 image, Dexter Folder employees and managers make up two teams, the Way Backs and the Have Beens. Consisting of men over the age of 30, the teams played on the diamond at the Unique Club. Note the clown doctor with the Red Cross armband, there to treat any "old men" who collapsed and needed "medical attention." (OHMA.)

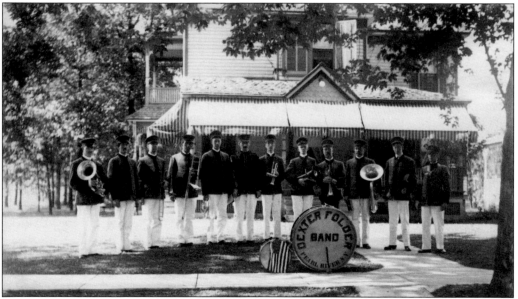

In 1909, New York State celebrated the tercentenary of explorer Henry Hudson as well as inventor Robert Fulton in towns along the Hudson River. The Dexter Folder band was made up of employees, many of whom were royal band members in their home countries. They were photographed on Central Avenue before going to the celebration in Nyack. Among those pictured are Porter Tygert, Oscar Kupari, Harold and Fred Hendericksen, Henry Carrie, Iva Tallman, and Chester Demarest. (Nancy Moore.)

Church Sunday school picnics were the kind of outings the whole family could enjoy, no matter one's age. In 1913, Walter Akhurst, a machinist and superintendent of the Braunsdorf Metal Foundry at Dexter Folder on Railroad Avenue for 41 years and superintendent of the Pearl River Methodist Episcopal Sunday school, poses for the camera on an excursion to picnic grounds in Spring Valley. (OHMA.)

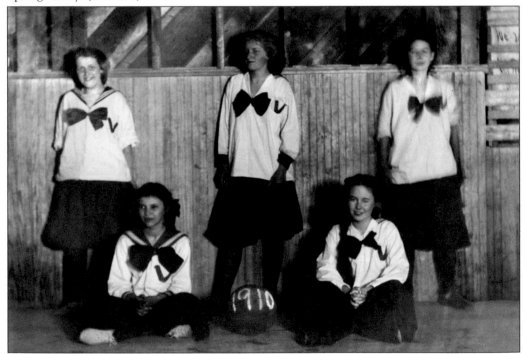

The wildly popular indoor-sport basketball has a long tradition in Pearl River. The Viking Lodge of the Pearl River Odd Fellows fraternal organization supported both girls' and boys' teams. Basketball was played in the gymnasium at the Unique Club on Pearl Street. This team of girls were the 1910 champions, defeating other teams from New Jersey and Spring Valley. (OHMA.)

With a view facing Serven's Lake boathouse, this image was taken in 1916, not long after the men's Unique Club Five won the championship basketball title. Among the champion Pearl River players perched happily in this old tree are the three Langer brothers—Arthur, Whitey, and Blackie. (PRSD.)

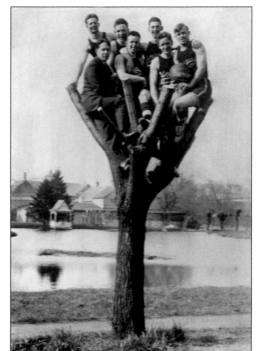

These proud athletes pose in the Odd Fellows Hall in 1910 as the champion basketball team representing the Pearl River Viking Lodge. The fraternal lodges were eager to sponsor sports teams because they provided a wholesome activity for the youth of Pearl River and earned the lodges money from ticket sales during the season. (OHMA.)

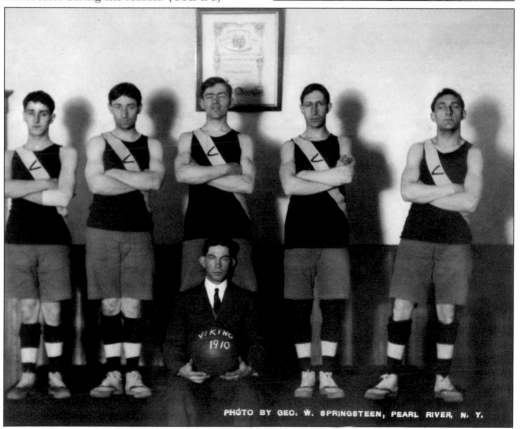

PHOTO BY GEO. W. SPRINGSTEEN, PEARL RIVER, N. Y.

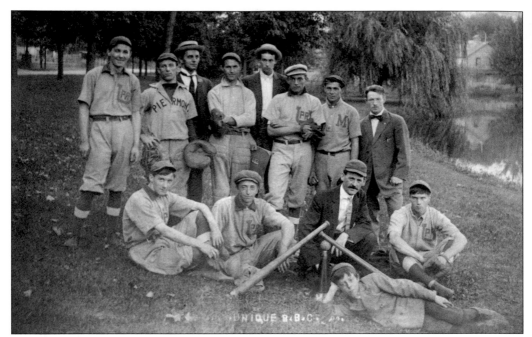

This motley assortment of baseball players poses on the shore of Serven's Lake in the summer of 1909. The reason their uniforms are from different teams is that the game was played during the off-season, when the players from Montvale, Pearl River, and Piermont played pickup games to stay in shape and keep their skills sharp. During the regular season, these men played with sponsored teams. (Brian Duddy.)

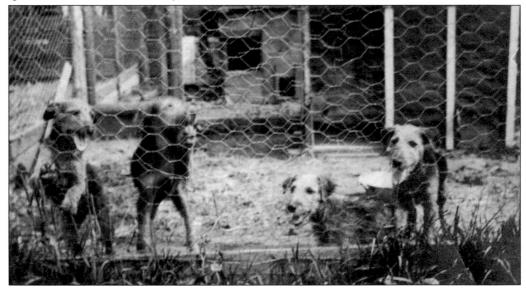

This kennel holds wirehair terriers belonging to Russell and Irving Hall Dexter at their home on Pearl Street. They were trained for hunting everything from rabbits to raccoons. Keeping dogs was popular because of the excellent upland game hunting for pheasants, woodcocks, and wild turkey in the woodlots that the families owned. Kathleen Bogert Dexter Baldwin Giroux, Russell Dexter's daughter, of Blacksburg, South Carolina, remembers that every dog pictured here was named Dexter. (KBDBG.)

Traveling on day trips was a fun and welcome activity among young people in Pearl River. This 1902 photograph was taken at a favorite area leisure spot in Piermont called the Fort Comfort Inn. Besides being able to swim in the Hudson, there was a castle-like structure where people could buy food, drinks, candy, and cigars. These folks are sitting on a cannon used by the shore guard in the American Revolution. (OHMA.)

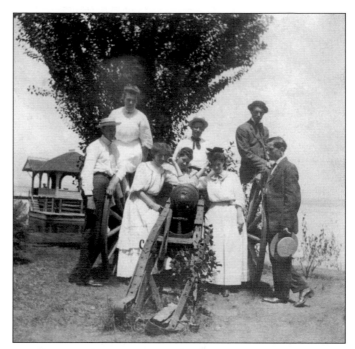

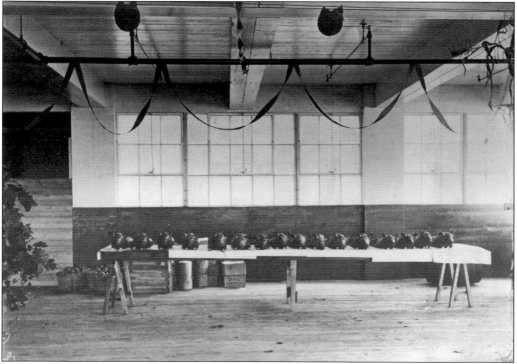

In the fall of 1920, the Dexter Folder Company held a Halloween Harvest dance social in the erector shop, where folding machines were assembled for final shipping. The area was cleared and decorated with dried leaves on the floor and dried corn shocks tied to every support column. This image of the preparation shows 16 whole-smoked roast suckling pigs, pickles, cheeses, and apples. To light the hall, 100 paper lanterns were hung from the ceiling. (PRPL.)

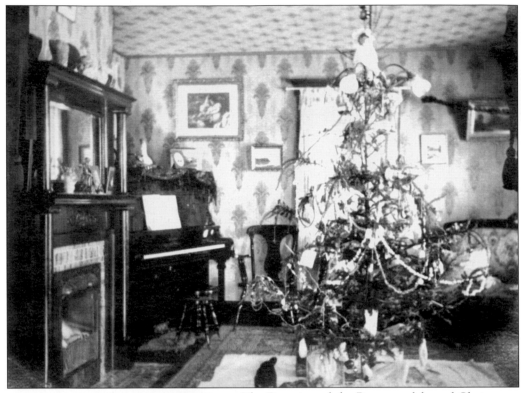

The Dexters and the Bogerts celebrated Christmas with a fresh-cut Christmas tree surrounded by presents in Anna Bogert Dexter's house on Old Middletown Road. Handmade ornaments hang from the tree set up in the parlor. The decorations are sparse by today's standards, but people in 1900 were more spiritual than material. The use of Christmas trees in America was only about 20 years old at the time. (KBDBG.)

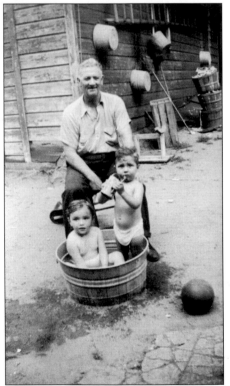

In this summer 1933 image, Tom Scarpulla fills a tub with water to cool off his grandson Carl Angioli (right) and his friend to beat the heat in the backyard of the Braunsdorf tenement he owned on South Main Street. The baskets in the background were used to carry oranges, from which juice was squeezed for the Whistle soda that was made in the garage behind them. (Angioli family.)

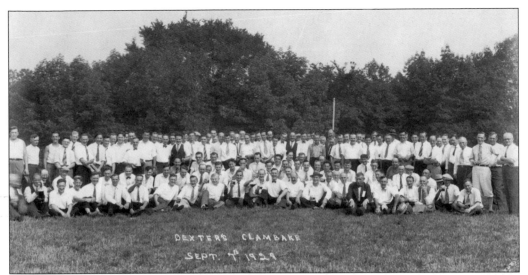

Taken on September 7, 1929—just prior to the Great Depression—this image shows Dexter Folder employees relaxing and having a good time. The clambakes at Dexter started around 1910 and continued until the early 1970s. The first clambakes were on Dexter company property, but when ownership of automobiles became more common, they were held at Kruckers Grove or Platzel Brauhaus in Pomona. (PRPL.)

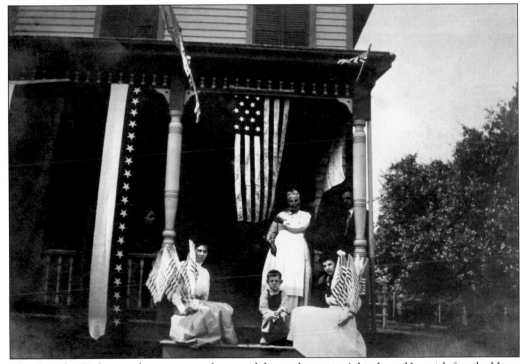

The Fourth of July was always a great day to celebrate the nation's birth and be with family. Here, Grandma Bogert's family is visiting with the Cordukes, Everetts, and Dexters in 1907. Among those pictured on this porch—decorated with patriotic 13-star flags and bunting—are Margaret Everett Cordukes, Russell Dexter, Mary Bogert Dexter, David Cordukes, Phoebe Bogert, and Irvin Dexter. (KBDBG.)

This 1912 photograph shows the families of Frederick and Harold Hendericksen, brothers who lived in the two-story house next to Pete's Barbershop on William Street. Both came from Norway and worked as patternmakers for Dexter Folder, where they played in the Dexter Folder band. Two of Harold's three sons were born in the United States, and he became a US citizen in 1913. But for reasons still unknown, Harold returned to Norway that same year. (OHMA.)

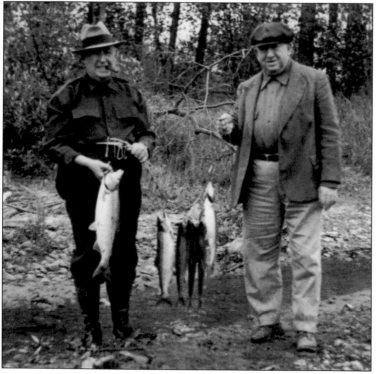

Trout fishing on the Hackensack River was a favorite pastime of George and Edward Oakley, co-owners of a taxi and a newsstand at 7 Central Avenue. Here, they pose for posterity around 1939 with a stringer of brown trout they caught. Since the days of early settlement, Native Americans used fish traps here and likely taught settlers how to make them. The construction of the reservoir in 1962 changed the ecosystem and destroyed the natural fishery. (Bob Mishcio.)

Just hanging around town with friends during one's leisure time is a pastime as old as Pearl River itself. Pictured here, top to bottom, are Jane Bockett, her sister Marion Bockett, Peggy Porter, and Florence Porter—all of whom sit on the fencing of the old brick high school building along Central Avenue in 1939. (Cameron family.)

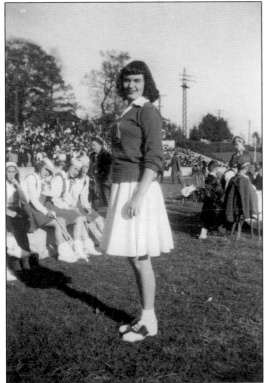

After-school leisure time for Gerri Crosbie was spent as a high school cheerleader, cheering for the football team. Her sister snapped this shot of Gerri at a football game between Nyack and Pearl River at Nyack High School just before she led the cheering squad in a routine. This image was taken in the 1940s, the golden age of high school athletics under Pearl River coach Ira Shuttleworth. (Nan Crosbie Fabio.)

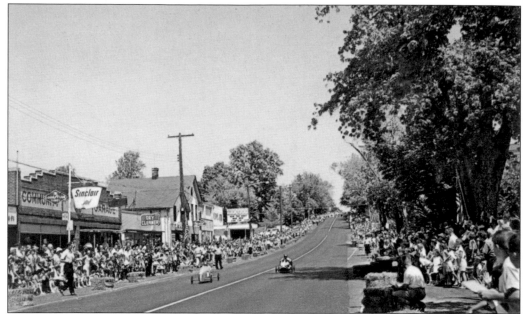

The Soap Box Derby was the brainchild of the John Secor Post No. 329 of the American Legion in Pearl River. In 1949, the post held a convention that included a parade, circus, block party, dance, and the derby for local kids. The race was held every year thereafter. But interest waned in the early 1980s, and the race was not held again till 1997. It has been a popular event again ever since. (Robert Knight.)

Leisure changed in the late 1940s with the advent of television. One of the most popular shows was professional wrestling, and one of the most beloved wrestlers was "Gorgeous George" Wagner, whose flowing golden locks and permed hair caught the imagination of kids at Pearl River High School. Facing the Central Avenue School, wearing costumes and wigs, is the entire membership of the Gorgeous George Fan Club. (Daughters of John Von Holt Jr.)

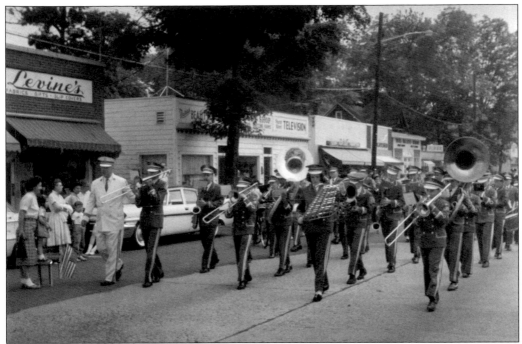

The Pearl River High School marching band parades down Central Avenue on the Fourth of July in 1959. Their leader is Dr. Herman "Doc" Scholl, beloved by every Pearl River student who played an instrument in school. Note the heavy wool uniforms and hats. After broiling in the heat, the kids were treated to soda and hot dogs in the basement of the American Legion Hall on Railroad Avenue. (SSEC.)

In 1964, a new form of popular entertainment called donkey baseball was played among firehouse volunteers. Here, a member of the Excelsior Fire Company bravely mounts his donkey to ride the bases after hitting the ball, pitched by a player who was also on a donkey. It is easy to imagine the laughs that were shared. This game was played against the Nanuet Fire Department at the Nanuet High School field. (Excelsior Fire Company.)

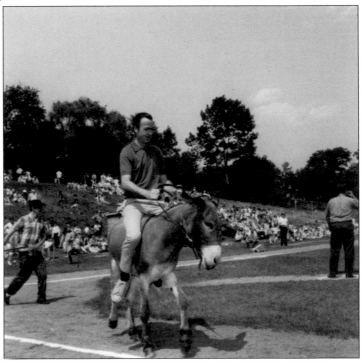

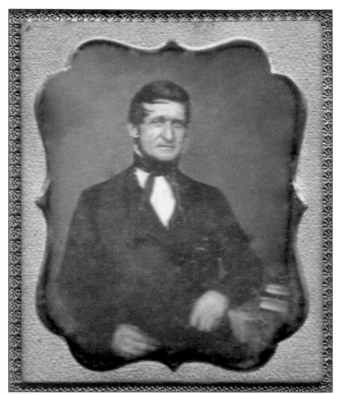

This 1845 ambrotype of John Isaac Blauvelt, born in 1804, is the oldest known image of any Pearl River resident. A farmer and staunch Baptist, he owned land from Gilbert Avenue north to Central Avenue, east to Sickletown Road, and west to South Main Street. Blauvelt was known to wear a high top hat on Sundays. He died on November 6, 1885, at the age of 81 and is buried in Pearl River Cemetery. (Brian Duddy.)

Margaret Serven taught Sunday school with Lu Lu Culp and Emma Comes at the Episcopal chapel on Central Avenue and also sang in the choir. Her husband, James A. Serven, owned the general store on Central Avenue. Sometime around 1904, she was struck by an Erie passenger train and severely injured. She lingered but finally succumbed to her injuries. Her husband sued the railroad and received financial compensation for her death. (SSEC.)

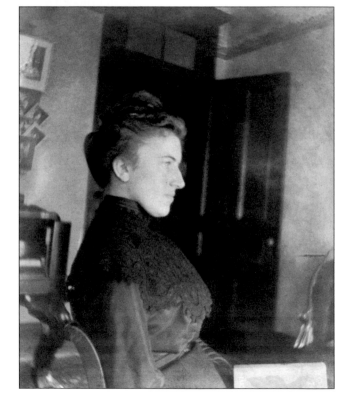

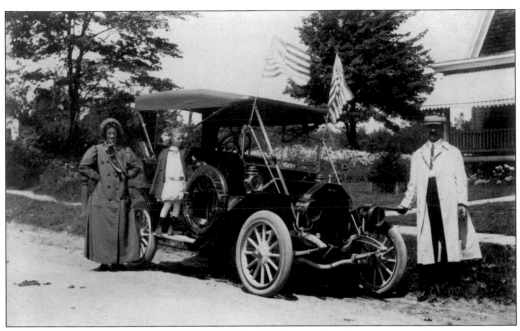

Dressed in long duster coats to protect their good Sunday clothes from the mud and dust, John A. Fisher, his wife, Daisy, and daughter Maggie take a ride in their Buick in 1911. Fisher was born on the family farm in the Pascack area of Pearl River in 1867. He owned a butcher shop called Fisher and Palmer Meats, located on Pearl Street around 1899. (Nancy Moore.)

Albert J. Slade Sr. (left) and Frank Pipe are pictured around 1908. Born in England, Slade, a building contractor and carpenter who built a number of buildings in town, attended the Episcopal church and lived in the house that is Louie's on the Avenue restaurant today. Pipe, a carpenter for the Dexter Folder Company, lived in a home he built on Summit Avenue. (Helen Cooper.)

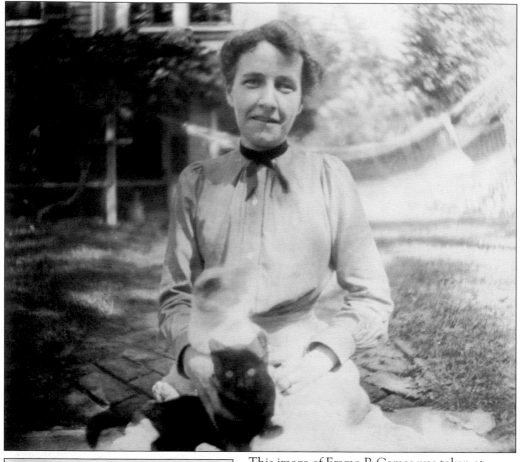

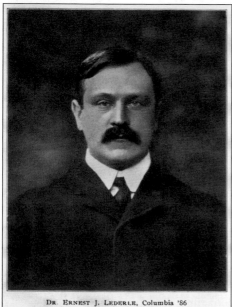

This image of Emma P. Comes was taken at the Comes family home and greenhouses that stood just north of the New Jersey line on South Middletown Road. Noted for her excellent soprano voice, she performed in many concerts at area churches with her brothers Edward William and Clarence and sister Anna. She also sang in the Episcopal chapel choir, which she led with Margaret A. Serven. (SSEC.)

Dr. Ernst Lederle served as New York City's commissioner of health and had the unfortunate task of releasing "Typhoid Mary" Mallon on her own recognizance from Blackwell Island. He purchased the Turfler farm on North Middletown Road and in 1906 founded Lederle Antitoxin Laboratories, where he developed many beneficial medicines that, even after his death from renal failure in an upstate sanatorium in 1921, established Lederle as a pharmaceutical powerhouse. (Pfizer Corp.)

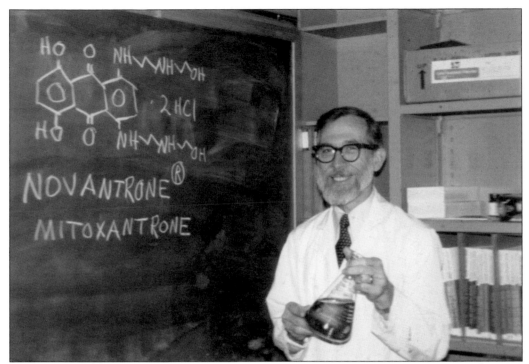

After earning a doctorate of philosophy in chemistry in 1950, Dr. Keith "Chad" Murdock was hired by Lederle Laboratories, where he worked from 1952 to 1991. He was drafted in 1954 and served at the Army Chemical Center in Maryland. His research led to the development and marketing of the chemotherapy drug Mitoxantrone for leukemia treatment. He still resides in Pearl River and is active in political, environmental, and social causes. (Martha Murdock.)

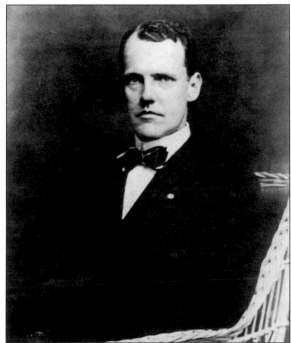

Irving Hall Dexter was the eldest son of Talbot Chambers and Mary Ellen Dexter. He went to local schools and trained for business with Dexter Folder. On Thanksgiving Day in 1900, he married Anna C. Bogert of Spring Valley in her father's home. Dexter purchased the Stage Coach Inn in Pearl River in 1903 and built a home on Pearl Street. In the late 1920s, he committed suicide. (KBDBG.)

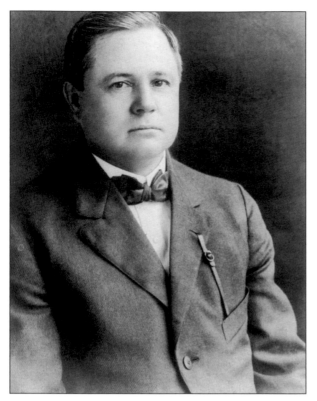

Jim Gilbert ran the Dexter Folder Company, as Talbot Dexter had little interest in business matters, only in inventing new machines. Jim was instrumental in establishing the Park Savings and Loan Company construction program for Dexter employees. He brokered the purchase of land on the south end of Ridge Street to build homes for employees that were backed by the bank; these homes are still lived in today. Gilbert Avenue was named for him. (PRPL.)

Margareta Beckerle was born in 1890 in Pearl River. Here, she poses for a portrait at a Nyack studio in 1900 as a very chic young girl. Raised Catholic, she was later a parishioner of St. Margaret's Church, of which she was a large benefactor. She persuaded her family members to donate the house and land where she grew up for use as a convent house, school gymnasium, and parking lot. (Beckerle family.)

Thomas C. Dexter, pictured here with his family around 1909, worked with his brother Talbot. Known as a one-man sales force, Thomas was always traveling, installing new machines and selling to new customers. His largest contract was the London Missionary Tract Society of London in 1904. Its Dexter-folded tracts were distributed throughout the British Empire. After receiving a gold watch for 30 years of service in 1925, he promptly dropped and broke it. (OHMA.)

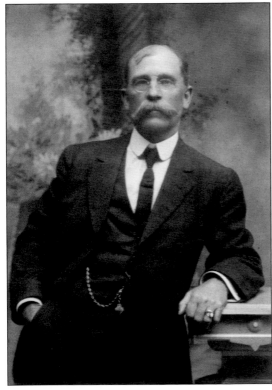

Samuel Cooper, pictured in 1902, came from an old Dutch family that changed its name from Kuyper to Cooper after the Revolution. He was a house painter by trade and built a home on the hill of Franklin Avenue. He was related to the well-loved "Aunt" Katie Cooper. His job in Pearl River consisted of finding lost animals and children, bringing home drunks, settling domestic disturbances, and running tramps out of town. (Nancy Moore.)

Cutting a fashionable figure, Lucy Kennedy Groom was born in Brooklyn around 1870 and moved to Pearl River to be near family. Her brother Fred Kennedy was the town's first police chief. In 1896, she joined the Women's Christian Temperance League and attended the Pratt Institute. A talented seamstress, she could sew a dress by sight without using a pattern, and was an expert on and retailer of American antiques. She married Jacob Groom around 1911 and lived on Old Middletown Road. (Nancy Groom.)

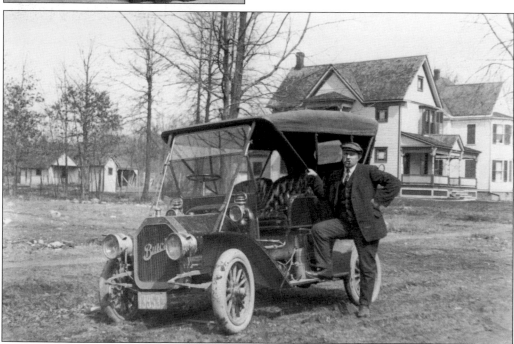

Otto Kossel, pictured here with his Buick on Central Avenue in 1909, was an enterprising man. He took photographs of points of interest around town and sold them to the *Pearl River Searchlight*, which then published them as postcards. He soon started his own postcard company. Kossel later opened a Buick dealership on Central Avenue next to the Hook & Ladder Company fire station. Around 1915, he partnered with Arthur Gunther at the dealership. (Nancy Moore.)

Laurence "Larry" Beckerle was born in 1888 in Pearl River, where he attended local schools and grew up in his family home on Washington Avenue. He started the Beckerle Lumber Company in 1940 and, through hard work, grew the business into a major supplier to contracting businesses in Rockland County after World War II. Today, with grandson Stephen at the tiller, Beckerle has grown to five locations. (Beckerle family.)

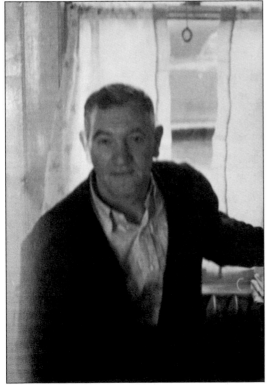

Italian immigrant Tomas Scarpulla purchased the redbrick Braunsdorf tenement at 96 South Main Street, where he lived with his extended Scarpulla and Angioli family during the Depression. He brought a recipe from Italy for making orange soda. Using his garage and with the family's help, he started a business making an orange drink called Whistle. He also ran the Gem Bottling Company and delivered his soda all over Rockland County. (Angioli family.)

Gertrude Eybers was a nurse who, along with her daughter Margret Sallander, established the Pearl River General Hospital in 1935 on an estate called the Chestnuts, the former summer home of New York City baker Fredrick Eigler, on South Middletown Road. The two women ran the hospital until illness forced them to stop working. The hospital was sold in 1949 and eventually closed in 1974. The building was demolished in 2002. (KBDBG.)

Alfred "Mooney" Bockett and his mother, Edith, pose for a picture in 1940. After World War II, Bockett returned to become Orangetown's building inspector. His interest in baseball inspired him to clean up an old lot on Jefferson Avenue for the first Little League diamond on Dexter Field. In 1964, he found a new venue at Anderson Field, which was later named Moony Bockett Stadium. He managed the Pearl River Giants to 16 championships. (Cameron family.)

Civil engineer Francis James "Jack" Wright came to Pearl River in 1922 and started a lumber business with James Titus, who ran off with the company's money. Wright then got into the contracting business with Joe Beckerle, forming Wright and Beckerle, which installed sewers at the Lederle plant and in town. Wright served on the board of the Pearl River School District and the Orangetown planning board. (Jean Massaro.)

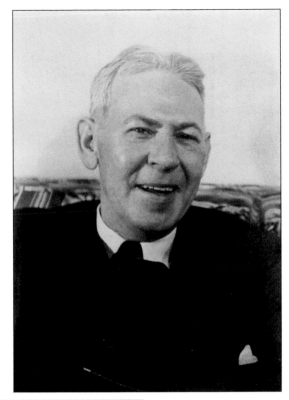

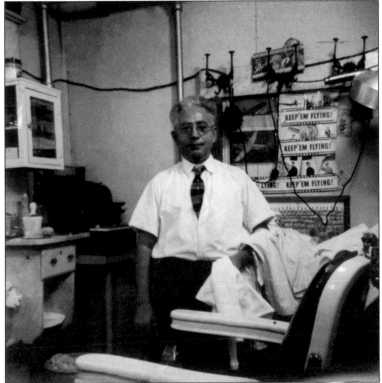

Victor Prezioso, a barber and World War I veteran, emigrated from Italy and bought the former home of Porter S. Tygert on Pearl Street. His barbershop was in both the Sanford Building and the structure housing LaBelle Printing. He started the American Legion in his shop and inaugurated the annual Memorial Day parade and service in Memorial Park. His Central Avenue shop is pictured on January 17, 1943. (PRPL.)

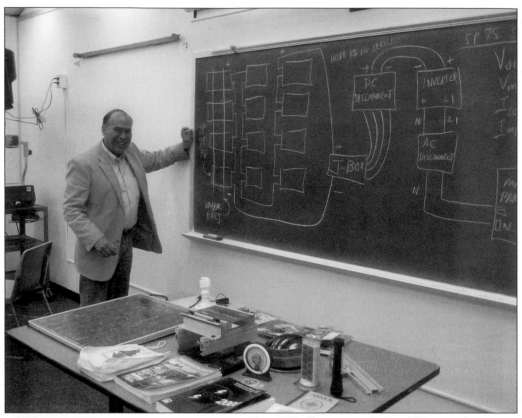

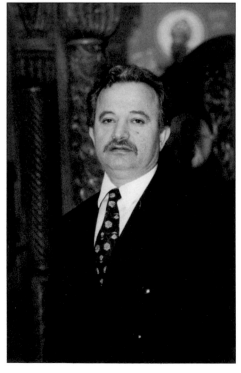

Tom O'Reilly grew up in Pearl River and was on the wrestling and football teams in high school. O'Reilly worked as a solar engineer in California and, after returning to Pearl River, established a successful cabinetmaking business. Today, he is a solar-energy consultant and professor at Rockland Community College and sits on the boards of the Historical Society of Rockland County, the Canoe Club of America, and numerous other organizations. (Tom O'Reilly.)

Originally from Greece, Niko Anagnostopoulus is the parish council president of SS. Helen and Constantine Greek Orthodox Church in the West Nyack/Pearl River area and has been involved in church affairs since its inception in 1963. When this photograph was taken in 1998, he was president of the journal committee. He is an energetic man, deeply devoted to the success of the church and the well-being of its members. (Niko Anagnostopoulus.)

Six

SCHOOLS

It is believed that schools have existed in Pearl River since the end of the American Revolution. In 1800, there was a school in Orangeville in the Naurashaun area known as District 7, but not much is known about it. In 1830, a second two-room school was built halfway up Orangeburg Road from Orangeville, with a Mr. Kennedy as schoolmaster. Head trustee Morris Van Houten recorded that trustees would visit the school and conduct oral examinations. A new school called District 8 was created in 1893, and classes were held above Berdef's Blacksmith Shop. The site was soon deemed unacceptable due to both noise and the constant smell of burnt horse hooves working its way up through cracks in the floorboards. In 1894, William Braunsdorf donated a large plot of marshy land, roughly on the corner of William Street and Franklin Avenue, where a large two-room schoolhouse was constructed. Two teachers, F.M. Greer and Effie Tanner, taught 63 students.

As Pearl River grew, so did the schools. In 1910, a District 7 Naurashaun elementary school was built on Orangeburg Road. Over the next 20 years, the District 8 school on Franklin Avenue was enlarged but could not keep up with the burgeoning population of school-age children. At the time, public schools did not teach courses at the high school level, and those who wanted more advanced education attended the many private schools in the area. In 1921, the marshy land between Franklin and Central Avenues was filled in, and by 1922, the cornerstone was laid for the brick Pearl River Union Free School District's new school for kindergarten through grade 12. This building functioned as a school for kindergarten through grade 12 until 1963, when the new high school was opened on East Central Avenue. A middle school was built in 1966 for grades six to eight. The William Street School, the first neighborhood elementary school, was built in 1950, followed by the Evans Park and Lincoln Avenue schools. The old fieldstone building in Naurashaun was also added to. Today, the Naurashaun elementary school is closed because it is not large enough to serve as a school under New York law.

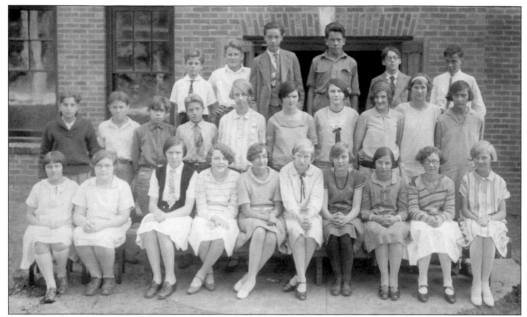

These children are sitting for their class picture at the new brick school on Central Avenue in 1924, just two years after school's opening. All are wearing their good Sunday clothes. Among those pictured are Rick Johnson, Hugo Oliver, Charlie Swift, Richard Naugle, George Springsteen, Sammie Scarpulla, Robert Edsall, Richard Cattell, Margaret Terhune, Leona Zuch, and Helen Kossel. (Nancy Moore.)

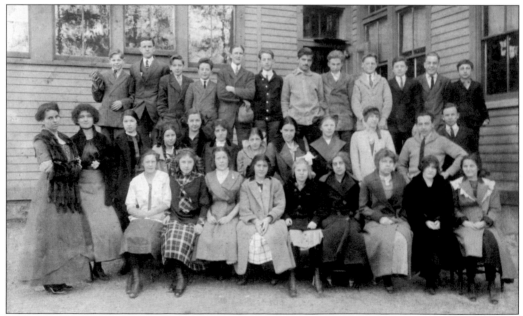

This photograph of the class of 1913 was taken in February of that year at the wooden school. Their commencement ceremony was held in the Odd Fellows Hall on Central Avenue and William Street. The students pictured here are, as listed on the back of the original class photograph, C. Langer, Felter, Tappy, Lowenstein, Clausen, Dolan, Cardell, M. Dexter, E. Eiserman, Fisher, C. Dosher, Katenkamp, and Post. (PRSD.)

Photographed by Thomas A. Dexter in 1940, this brick school building cost $245,000 in 1921 to construct and opened in 1922. The land was a swamp when purchased, and it was filled in with soil from the cornfields of the Van Houten farm near the Hackensack River. Children would find arrowheads in the fill. By 1964, when the new high school was built, the building was abandoned, and it was torn down in 1983. (Robert Knight.)

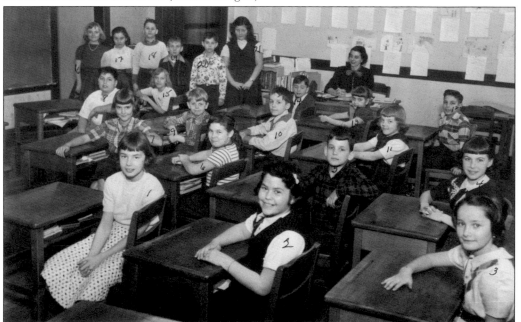

The interior of a classroom in the brick school is pictured in 1962. Teacher Antoinette Salerno poses with her fourth-grade students. Her students, not all of whom are identified, include Barbara Krucick, Judy Hoinigstock, Barbara Kunzie, Kathleen Powers, Julian Scala, Cheryl Jones, Nancy Schneider, Stuart Bornstein, Donald Nelson, Lenard Beers, Phyllis McElroy, David Manchetti, Cathy Macintyre, Patricia McCroskey, Carolyn Holmes, Diane Floyd, Robert Bergman, Paul Smith, Walter Ainsworth, and Carol Bovee. (PRSD.)

The interior of the Ridge Street library shows the crowded conditions there in 1957. As early as 1955, the Rotary Club and the American Legion pushed the school district to build a larger, more modern building. After a study showed the need for a new library to meet the needs of the growing community, land was purchased on Franklin Avenue. (PRPL.)

This 1964 photograph shows the interior of Pearl River's new library. With the staff getting ready to start its day, all is shiny and new. The Junior JCs, a club made up of young people, moved all of the books from the old building on Ridge Street to this brand-new building. It was a real community effort to restock the library. In 2013, the library celebrated its 50th anniversary. (PRPL.)

The Pearl River Library began as a shelf of books in a one-room school around 1870 on today's ShopRite property. In 1894, it was moved to the Unique Club reading room, then to a small store on Central Avenue, and on to the new school building in 1934. From there, it moved to Ridge Street and then to its present location in 1963. The library was extensively enlarged in 1992 and is seen here while under construction. (PRPL.)

The card catalog was an iconic tool in the library user's kit when searching for information. Here, two children in the children's library search for the information they need. In 1995, the Pearl River Public Library embraced new computer technology for information searches, joined the Ramapo Catskill Library System, and installed an online catalog. To this day, the library staff is constantly improving search capabilities for patrons. (PRPL.)

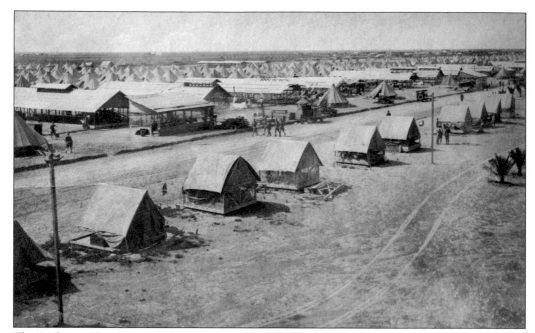

This is the encampment of the 27th Infantry Division along the Mexican border. Among these tents where the men camped out is Fred Kennedy's tent. There was a lot of movement along the border, but the bandits were hard to catch. Although Kennedy and his division followed Gen. John "Black Jack" Pershing into Mexico in pursuit of Pancho Villa, no luck came of it. Villa evaded capture. (Mary D. Kennedy.)

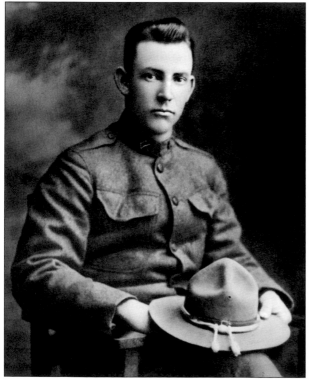

The American Legion Post No. 329 is named after this unassuming man, who showed his true mettle in a time of crisis. John H. Secor enlisted in 1917 and fought in France where, after his platoon commander was killed, he led an attack against German lines and was wounded twice in the assault. His actions provided an example to the troops he led, showing uncommon bravery and devotion. He was posthumously awarded the Distinguished Service Cross. (American Legion No. 329.)

In 1930, Congress authorized funds for the mothers of fallen sons to visit and decorate their graves. Here, Dorothy Secor lays a wreath at her son's grave in France. She lost her son John on October 16, 1918. Secor Boulevard was named in his honor. The Pearl River post of the American Legion honors Secor and all the fallen of Pearl River every Memorial Day in Memorial Park following the parade. (American Legion No. 329.)

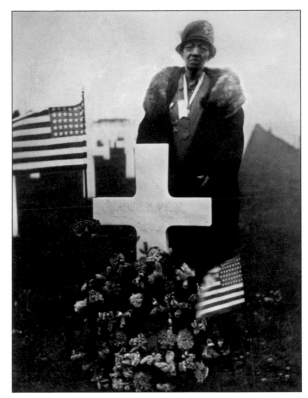

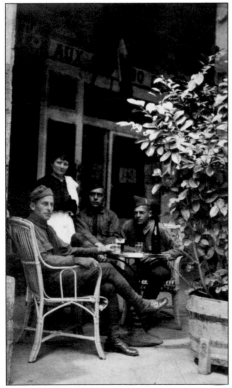

These doughboys are enjoying Paris while on rest and relaxation in the "City of Light." Sitting in this café on the Champs-Elysées are Ed and Arthur Dexter, the two Dexter family members from Pearl River who went to war in France with the American Expeditionary Force in 1917. Ed is seated, and Arthur is sitting next to him in the center of the photograph. The other soldier is unidentified. (KBDG.)

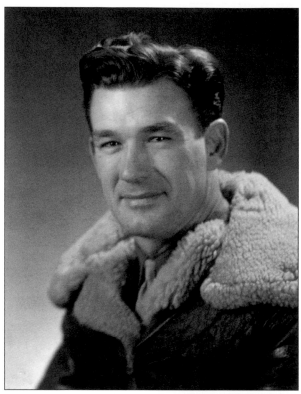

Edward M. Covey came to Pearl River in 1920. In a high school baseball game, he hit the longest home run in Pearl River history, over 500 feet. During World War II, he served in England as a mechanic with the US Army Air Corps. Afterwards, he worked for Fred Holt Company as a carpenter, building Cape-style homes. He and his family lived in a home he built at 91 South William Street. (Marion Covey.)

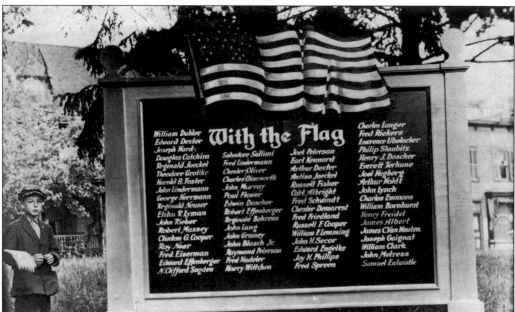

Pearl River's honor roll was placed in Braunsdorf Park by businessmen and families whose sons served in World War I. The names read like a who's who of the history of local families. During World War II, a larger honor roll was put up in the same place by Secor Post No. 329 at the insistence of barber Victor Prezioso. Of all the names listed, only Staubitz and Secor had streets named after them. (OHMA.)

In 1919, Fred Kennedy and the men of the 27th Division marched in the victory parade on Fifth Avenue in New York. Here, their commander, Maj. Gen. John O'Ryan, is on horseback parading past the altar of the fallen in front of the New York Public Library. Originally a National Guard unit made up of men from New York, its nickname was "O'Ryan's Roughnecks." The men fought at Flanders and the Somme. (Mary D. Kennedy.)

Marching at the Memorial Day parade of 1924 are such notable veterans as Fred Kennedy, Victor Prezioso, Edward Graney, and others. They are marching down Central Avenue past the Grenada Theater, headed to Memorial Park. On the center right is Fred Kennedy's uncle Joseph Kennedy. All three services—Army, Navy, and Marines—are represented. Notice the small boy with polio trying to keep up. (Mary D. Kennedy.)

The first Pearl River Baptist Church was built in 1817 where the parking lot of ShopRite Liquors is today. The second church, pictured here, stood at the bend in Old Middletown Road east of the cemetery. Many years later, this church was torn down to make way for the home owned by renowned child psychiatrist Dr. Anna Munster. Dr. Munster's son, who lives in the home today, is blues musician Daniel "J" Jocubovitch. (HSRC.)

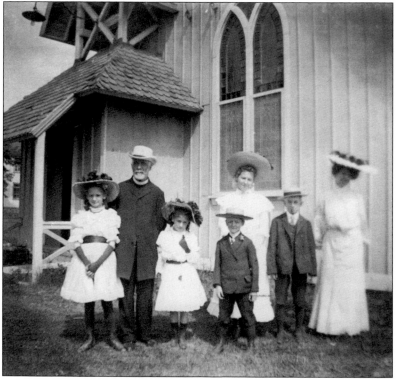

The Episcopalians built their chapel facing Central Avenue, where the Pearl River Saloon stands today, and held their first service on December 4, 1887. Photographed by Clarence Combs in 1900 are, from left to right, Agnes Tappy, Rev. John Howell, Bessie Tappy, Albert Slade Jr., unidentified, Ned Tappy, and Lu Lu Culp. They are standing near the Episcopal chapel, which stood on Central Avenue. (SSEC.)

The cornerstone of this Episcopal chapel was laid on October 1, 1887, and the first services were held two months later on December 4. With the structure being just 200 feet away from the Muddy Brook, the congregation was frequently unable to hold services here because of flooding. The great storm of October 3, 1903, put the chapel in the middle of a lake for a week. A new location was planned. (SSEC.)

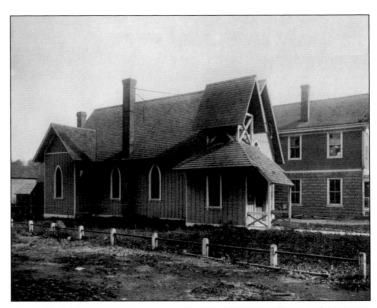

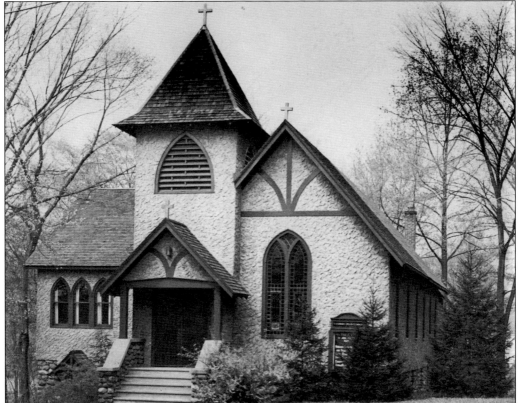

The Episcopal congregation purchased land on the corner of John Street and Central Avenue and had their church moved from lower Central Avenue to this spot in 1926. While it was located on Central Avenue and John Street, the congregation experienced growing pains and expanded the church (pictured). This church was adequate for the congregation's needs until the late 1950s. Today, the church building is Sitzmark Ski Shop. (SSEC.)

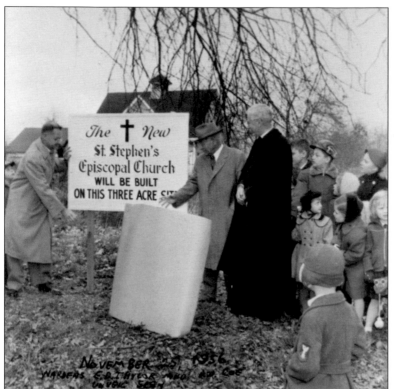

Rev. Vicar Ernest W. Churchill broke ground on a three-acre site on Ehrhardt Road in 1956. The Episcopal church is located at the intersection of Pierce Parkway and Ehrhardt Road. In 1965, the church council decided to build a large sanctuary with structural timbers of laminated wood that could hold great weight. Once this project was finished, a rogation celebration was held. (SSEC.)

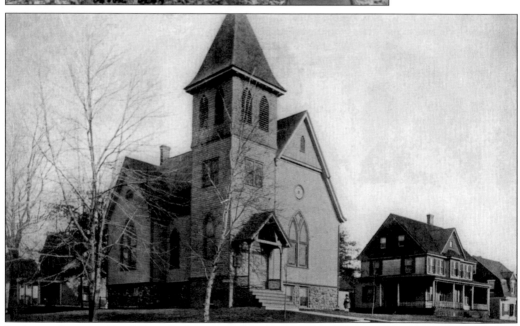

Lutherans began in Pearl River by forming a church council on February 20, 1901. Its first president was John Doscher, with Herman Rohers and Claus Gerdes as trustees and Frank Reilly, Gustav Loescher, Gustav Lindstrom, Fred Oldenbuttel, and Harry Meyers as members. The church grew with the rise in Pearl River's Scandinavian Lutheran population, and in 1925, the old wooden church was moved next door. (Robert Knight.)

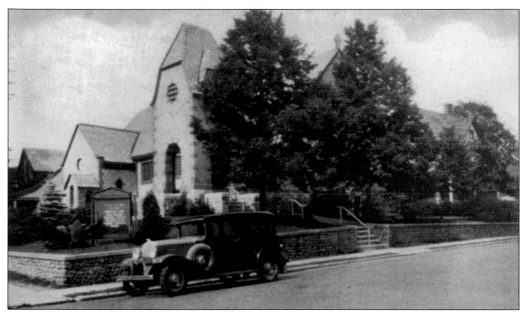

This new brick Lutheran church was built in a year and served the community and new employees who came to work at Dexter Folder and Lederle Laboratories. The beams that support this church resemble the spars of a ship. Many early parishioners were shipbuilders in their native Scandinavia. The church was enlarged to include the school building and continues to serve the Lutheran community today. (Robert Knight.)

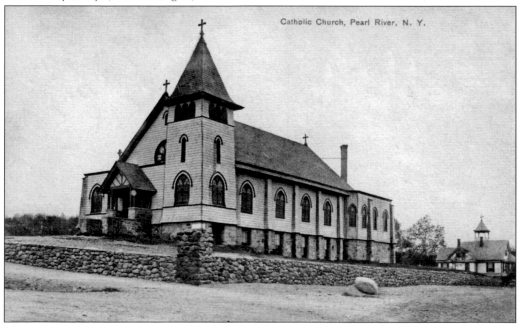

Catholics in Pearl River first gathered around 1893 in a home on Ridge Street. As more Catholics arrived, they attended St. Agatha's in Nanuet or St. Catherine's in Blauvelt. In 1900, Father McCormick purchased land from Joseph A. Fisher, and ground was broken for St. Margaret of Antioch on May 19, 1901. This wooden building served its congregants until 1929, when it burned to the ground in a fire caused by someone burning leaves. (Robert Knight.)

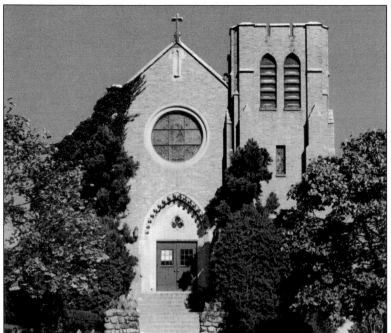

Pictured is the new fireproof brick St. Margaret's church that was built in 1931. Originally, it was to be constructed where the public library is today, but because of the high cost of brick construction, the parish chose to build on the original site, where the church stands today. The only design change was the addition of a cupola over the bell tower, devised by local architect Vincent Acocella. (Robert Knight.)

The Beth Am "House of the People" Temple of Pearl River stands at the end of Madison Avenue. Organization and planning of the synagogue began in April 1963, and land was purchased in 1966. When this photograph was taken in December 1967, ground-breaking ceremonies were being held, but it was a year before actual construction started. The ceremony was conducted by Rabbi Milton Weinberg and Rev. Wilber O. Daniels. (Beth Am.)

This tabernacle holds the sacred scrolls of the Torah, the Jewish book of learning. On October 3, 1969, Rabbi Milton Weinberg purchased it for the temple. Made in 1850 in Czechoslovakia, it was one of hundreds confiscated by the Nazis during World War II and was scheduled for destruction before it was saved. It is now enshrined in the tabernacle and used during services and on special occasions. (Beth Am.)

Marty and Miriam Groupp show the assembled congregation an architect's rendition of the original synagogue on Madison Avenue. The temple not only serves Pearl River, but also Nanuet, Orangeburg, Montvale, and Park Ridge. Spiritual leader Rabbi Daniel Pernick holds the honor of being the longest-serving religious leader in Rockland County—28 years as of 2013, the year the temple celebrated 50 years of service in the community and county. (Beth Am.)

Organized in 1797 by the Blauvelt family, Baptists constructed the first church in Pearl River. This church was built in 1817 on Old Middletown Road, where the ShopRite Liquor parking lot and Bogert burial ground are today. The church was moved a half mile south, where the third (and last) structure was built in 1859. The Baptists then left Pearl River permanently for Nanuet after arguments over religious dogma. (HSRC.)

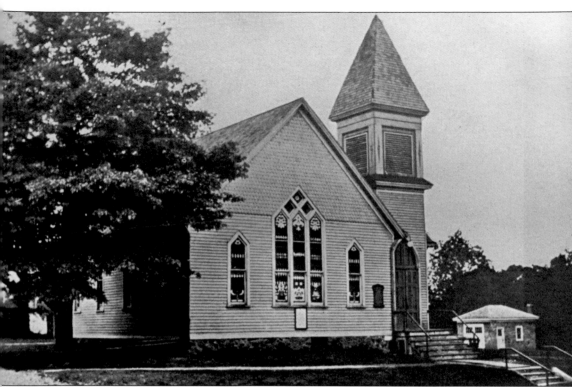

According to church historian David Slagen, this is the earliest known image of the United Methodist church. This newly completed church was erected as part of Talbot Dexter's 1894 Franklin Avenue improvement plan. William Springsteen built it for $1,500 on land donated by Mr. and Mrs. George W. Braunsdorf, who lived across the street. That Braunsdorf home is now the Wyman Fisher Funeral Home. (UMC.)

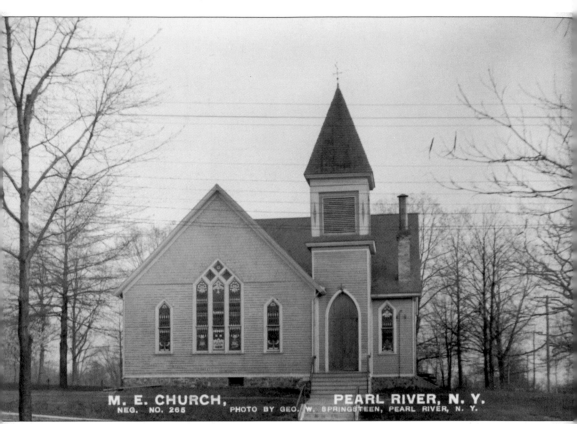

This 1912 photograph of the Pearl River United Methodist Church was taken by George Springsteen. The bell tower roof was repaired after lightning struck it and caused a fire during a storm in August 1901. Only quick action by the people in the neighborhood prevented this act of nature from becoming a complete disaster. This incident prompted townsfolk to organize a fire company. (UMC.)

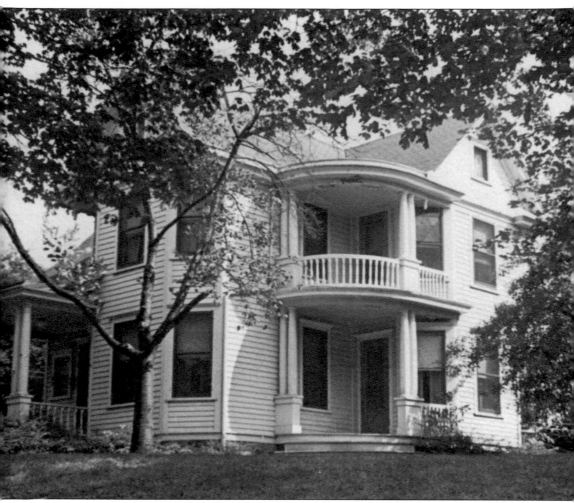

The need for a permanent domicile for ministers of the Pearl River United Methodist Church was filled in 1902 when carpenter William Springsteen was asked to build a parsonage. After a design was approved by the congregation, this beautiful two-story home with semicircular balconies on the west side of the house was constructed. The cost was $1,787.94, and it is still used by the ministry today. (UMC.)

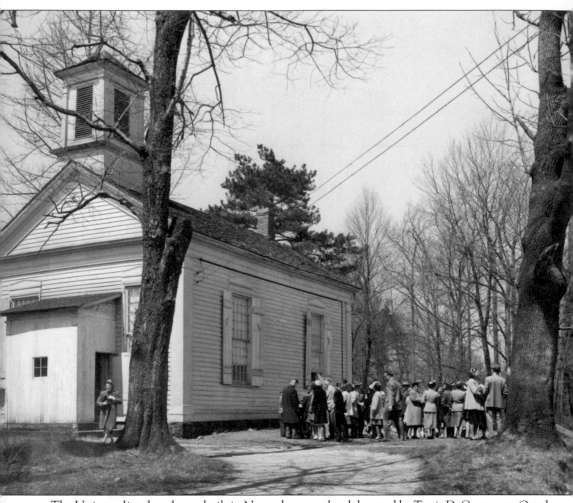

The Universalist church was built in Naurashaun on land donated by Tunis D. Cooper on October 2, 1855. Reverend Rainor was its first pastor. Interest in Universalism waned, but the Sunday school, taught by a Miss Mackenzie, was well attended for many years. The Presbyterians formed in 1927 and used this building until 1956, when they bought three acres of property on the other side of the Naurashaun Brook. (NPC.)

When a new Presbyterian church was built on Sickletown Road, the 1855 brass bell was removed from the old church and kept in Chief Kennedy's front yard. While having coffee one evening, his daughter-in-law heard voices outside the Kennedy house, went out to investigate, and saw a car driving away. She threw her coffee mug at the car, shattering the back window. The bell was gone forever, and so was her mug. (NPC.)

This modern Presbyterian church is located on Sickletown Road on three acres of land purchased to accommodate an expanding congregation. Agreeing on final design created a firestorm of controversy among the congregants. A vote was taken on December 19, 1960, resulting in the modern architectural design seen here in 1965. Many church members were so upset that they resigned from the church in protest. (NPC.)

SS. Constantine and Helen Greek Orthodox Church began in Rockland through the efforts of Gus Pappas. In 1962, he canvassed area Greek Orthodox families to determine if there was interest in forming a congregation. Many were interested, and a charter was granted by the archdiocese. In 1963, four and a half acres of land were purchased on Marycrest Road, and, with $11,000 in raised funds, a wood-frame church was built in 1967. (HCGOC.)

In 1970, SS. Constantine and Helen Church held its first Greek festival—an annual June event everyone looks forward to. In 1999, after years of planning and fundraising, a newer, larger church was completed. In receiving relics of the saints its name represents, the church was consecrated in 1999. Pictured during the Great Vespers Mass of Consecration are His Grace Bishop Demitrios of Xanthos and his retinue. (HCGOC.)

DISCOVER THOUSANDS OF LOCAL HISTORY BOOKS FEATURING MILLIONS OF VINTAGE IMAGES

Arcadia Publishing, the leading local history publisher in the United States, is committed to making history accessible and meaningful through publishing books that celebrate and preserve the heritage of America's people and places.

Find more books like this at
www.arcadiapublishing.com

Search for your hometown history, your old stomping grounds, and even your favorite sports team.

Consistent with our mission to preserve history on a local level, this book was printed in South Carolina on American-made paper and manufactured entirely in the United States. Products carrying the accredited Forest Stewardship Council (FSC) label are printed on 100 percent FSC-certified paper.

MADE IN THE USA